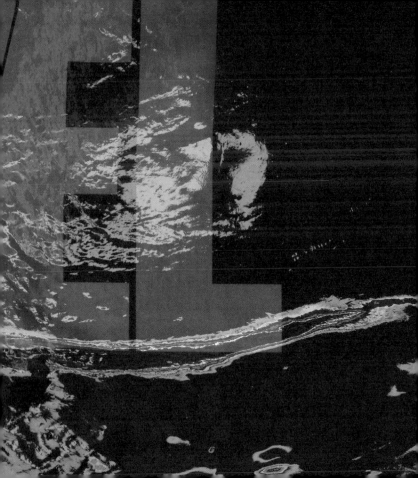

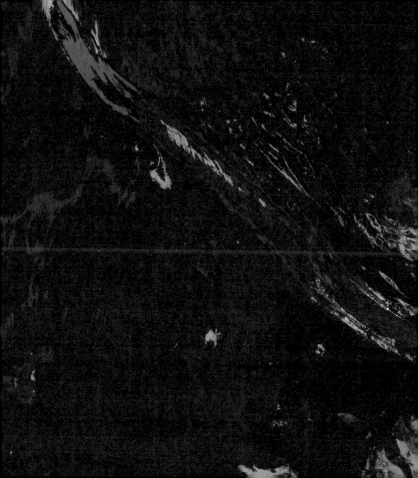

FUEL

Alphabet City no. 13

edited by John Knechtel

An **Alphabet City Media** Book
The **MIT Press** Cambridge, Massachusetts, and London, England

MIT Press books may be purchased at special quantity dis-
counts for business or sales promotional use. For information,
please email special_sales@mitpress.mit.edu or write to
Special Sales Department, The MIT Press, 55 Hayward Street,
Cambridge, MA 02142.

This book was set in ITC Machine, Helvetica Neue, and Hoefler
Text by Underline Studio and was printed and bound in China.

Cover and title pages photographs:
Paul Weeks

ISBN: 978-0-262-11325-0
ISSN: 1183-8086

10 9 8 7 6 5 4 3 2 1

12 Introduction
John Knechtel

18 Oil Futures
Imre Szeman
What stories do we tell ourselves about the coming end of oil? What stories should we tell instead?

36 Oil Fields
Edward Burtynsky
What's in store when the looming hangover from a dying oil party hits.

58 Tanker Crash
Robin Collyer
Every picture tells a story, especially if the subject is oil and/or flames.

70 Resource Fields: Gas Urbanism & Slick Cities
Mason White
Networked technological infrastructures and fantastical utopias are fueled by an overexcited oil and gas market.

94 Occupying the Caspian Sea: A One Hundred Year Plan
Maya Przybylski
Anticipating the post-oil future of a complex ecosystem.

124 Oil Rich Niger Delta
George Osodi
Nigeria's oil reserves generate vast wealth, but for the people of the Niger Delta poverty, conflict, corruption, and pollution are a daily reality.

164 The Post-Carbon Highway
Geoffrey Thün and Kathy Velikov | RVTR
A proposal to intelligently retool highway infrastructure for an era of new fuels.

212 Woodpiles
Vid Ingelevics
Can a pile of wood waiting to be burned also be seen as a form of vernacular architecture? Can the structure of a woodpile betray cultural differences?

228 La Bouche du Roi
Romuald Hazoumé
Beninese artist Romuald Hazoumé's sculpture warns against human greed, exploitation, and enslavement.

236 Velo-City
Chris Hardwicke
Dedicated infrastructure for bicycles holds transformative potential.

264 Blankety Blank
Candice Tarnowski
A burnt forest of wool and rabbit fur sits atop flannelette
tectonic plates in this nowhere-world geological specimen.
Text by Susannah Wesley

278 Tar Sands
Kelly Doran
Reprogramming resource development in
Northern Alberta.

308 A.I.R.
Sara Graham and Lateral Architecture
Live your life at a new height in A.I.R., the ultra-efficient
portable residential unit that can be attached to any building.

328 Culobocca
Robert Kirkbride
A placeholder for the perfect fuel.

348 Contributors

The carbon-burning system that fuels our lives is all-encompassing and unsustainable. We will have to spend forty-five trillion dollars over forty years, by the International Energy Agency's estimate, to convert half of the world's annual energy requirements to renewable sources (we can eliminate the other half through conservation). To achieve these goals by 2050 we will have to spend as if we are engaged in a world war. Dozens of nuclear plants, ten thousand wind turbines, solar panels in the hundreds of millions, hundreds of geothermal and biomass plants, and more, must be built every year, along with increasingly energy-efficient cars, buildings, and factories.

The scale of this enterprise is more than unprecedented—the US–Russia moon race cost one thousandth as much and took a quarter of the time. Walking away from our petroleum-based life is a task that stretches the imagination, even as the imperative to do so grows.

Edward Burtynsky's epochal photographs bring us face-to-face with the gigantism of our fuel complex: his landscapes are consumed by oil rigs, lakes of tar sands tailings, looming refineries. In each image, the magnitude of the subject exceeds the frame, defeating comprehensive perception. And apparently we have only just begun to explore the potential scale of petroleum's built form. Mason White describes recent "utopias of infrastructure" whose purpose is to reshape the land in ever more ambitious ways. The Siberian gas industry builds instant cities made of "tankers, platforms, ports and pipe networks ... urban form in a gaseous state" even as engineers in Dubai manufacture land with Dutch dredgers, creating new island communities in fantastical shapes meant to be viewed from the air. These utopias project oil's power across vast terrains of time and space. In a kind of apotheosis of petroleum-engineering megaprojects, the terra forming will go even further in the next few decades, scraping the deepest ocean floors for methane, chewing through mountains of shale to extract oil.

These new installations advance unchecked, even as previous generations of technology fall into desuetude. Petroleum alters the land forever, leaving Paul Bunyan–sized cuts and abandoned, decaying infrastructure. In response, Kelly Doran and Maya Przybylski visualize the work that could reclaim two segments of

oil's blastscape: Canada's tar sands and the oil rigs of the Caspian Sea. Marrying brutal realism with affirmative design strategies, they turn oil's legacy on its head, imagining new uses for the detritus of yesterday's petroleum technology: cranberry farms, wildlife sanctuaries, research stations. And Przybylski ponders, "Beyond that moment when the last barrel of oil leaves the seabed, the Caspian will remain. Is it possible to plan for this moment by extending the momentum generated by the oil operations into the post-oil phase of the sea, rather than passively anticipating a postindustrial wasteland?"

In many other places, the petroleum wasteland is already an all-encompassing fact. Here, distant ecological futures are made irrelevant by painful local reality. George Osodi's photographic project—"Oil-Rich Niger Delta" is its sardonic title—reveals lives lived at the ass end of oil. Pipes and wellheads have landed in Nigeria like parasitical alien life forms, spilling and burning oil in the process of sucking it up. The oil wealth they create vanishes, but the oil itself is ubiquitous, contaminating fishponds and farmlands, literally engulfing communities in an embrace they can neither overcome nor escape. These people endure more than just poverty; they must live in the destruction caused by petroleum itself.

Fuel is more than an environmental problem. It is a matter of justice. Next door to Nigeria, Bénin also produces oil. Artist Romuald Hazoumé's sculpture *La Bouche du Roi* renders oil as king, the source of all beneficence, all woe. The title references the mouth of the Mono River, the place where slave traders stowed a million children, women and men as cargo for the Middle Passage

to their new world. The medium is petrol cans, which recreate the plan of the slave ship *Brookes*. The work offers little in the way of consolation to Hazoumé's fellow Béninese. Servitude is the historical continuity here. Justice is absent.

The pathologies of the petroleum economy are endemic, and their scale so vast as to confound ready comprehension, or even perception: social injustice, war, international terrorism, economic fragility, global warming, ecological devastation. There will never be a clean and final break. The work of building a future on new forms of carbon-free energy must address all of the intractable legacies of our past and present dependence on oil. Ingenuities of infrastructure conversion and environmental conservation will only take us so far. To succeed, the project must strike at the roots of energy injustice and create access to sustainable energy everywhere, not just in the rich, hyper-developed regions of the world with the ability to capitalize infrastructure conversion.

The daunting complexity of the problem of switching from oil drives an attendant fantasy: that of a total solution, a single, perfect fuel that will liberate humanity. This monological thinking is slyly satirized in Robert Kirkbride's sculpture *Culobocca*, which offers the phantasm of such a fuel powering a machine of ultimate efficiency. This fantasy will itself be our downfall, if we do not learn to think in terms of massively parallel solutions instead of a magic bullet. As Imre Szeman points out, we simply can't afford the techno-utopian "dream that a coincidence between technological discovery and historic necessity will emerge now" to save us.

Instead of attempting to somehow repeat the one-fuel logic of the oil economy, we need new ways of thinking so that we can

design our way out of our current energy system and into a world of multiplexed sustainable fuels. We need to invent—and engineer—technologies for combining many energy sources, while at the same time managing the political complexity of wiring public-sector research and investment to private-sector dynamism and capacity. To truly succeed, the solutions we create will have to be accessible worldwide, to poor countries as well as to rich, for villages and for giant metropoles; and the results will have to serve the interests of citizens as well as those of capital.

In engineering the coming global energy conversion, we must reach far beyond the goal of zero carbon. In "Post-Carbon Highway" architects Geoffrey Thün and Kathy Velikov of the firm RVTR reinvent a critical element of our economic infrastructure for an era of low-carbon energy while building-in additional orders of economic and environmental benefit. Thinking in multiple dimensions, Thün and Velikov plan an increase in the highway's "bandwidth." Instead of a single-speed strip of tarmac for gas-fueled vehicles, this trunkline widens, branches and blooms into multipurpose levels and corridors, not simply carrying goods and people but also generating energy, commerce, and environmental mitigation. These visionaries' work is a convincing demonstration of how the conversion to a post-carbon world can open opportunities well beyond the mere cutting of emissions.

Chris Hardwicke's Velo-City abandons fuel altogether. His proposal for a network of commuter bicycle tubes nested into the city's existing fabric of road, railway, and power corridors promises a transformative means of moving through the city. Hardwicke's bikeways would allow cycle-commute times similar to those of

transit while reinventing our view of the urban scene and our way of life within it—stripping out external energy sources is a mere byproduct.

The future is energy pluralism. Once our infrastructure is able to interconnect different fuel types and distribution systems, our economies will be liberated from their damaging addiction to a single raw material. In this new era, aggressive market-based competition between sustainable fuels will flourish only in the context of publicly managed energy grids, design strategies that maximize the just distribution of energy worldwide, and government-funded long-term basic research. The correct balance will be difficult to achieve. But, as this volume suggests, rethinking fuel can open bright futures for the world.

—JK

IMRE
SZEMAN

RES

The rising cost of a barrel of oil (at record levels as of mid-March 2008) is now the basis of a drama played out daily in the forefront of our consciousness, pushed there by innumerable news stories as well as by the shock of heating prices and cost of a tank of gas. With the spike in the price of the primary fuel for so many of the operations basic to contemporary life comes a jump in the price of everything else. Food, for example, is often trucked or flown thousands of miles from field or factory to store shelves, which means that it will constitute an ever higher proportion of our daily expenses in conjunction with the ballooning cost of oil. Even the cheaper alternatives that some of us might adopt in order to step out of the oil economy are increasing in price: like food and oil, bicycles originate elsewhere, as does the rubber in their tires and the alloys in their frames—materials that also have petrochemicals in their very makeup.

Beyond the question of cost there are other very real and justified anxieties. We know that our constantly increasing demand for and use of oil is having a destructive effect on our fragile environment. We are also fearful of the implications of the eventual disappearance of oil: the massive infrastructure of what we might call "oil capitalism" that has developed around it will (for better and for worse) clearly soon be in peril.

In the face of the daily deluge of news about oil and its possible futures, the left end of the political spectrum has offered little more than moral hectoring to use less oil or none at all, a position that tacitly accepts liberal individualism and consumerism as the sole factors able to drive social change. Of course it would be better if we all drove less, or if governments

insisted on higher fuel standards for all vehicles, but it's clear that those small changes cannot be the solution to the problem of the energy needs of a human polity expected to grow to nine billion by mid-century. The left has seemed to resist thinking too deeply about the larger consequences of the petro-economy and what, if anything, will come after its decline. What might a serious left position on oil capitalism—and its aftermath—look like? As a way of moving toward an answer to this question, we need to look at the three dominant social narratives concerning oil's futures today: strategic realism, techno-utopianism, and eco-apocalypse.

Strategic Realism

Strategic realism views contemporary geopolitical maneuvering as the inevitable outcome of competition for access to goods and resources: chief amongst these being access to oil. As Daniel Yergin notes, oil arrived on the geopolitical stage when, at the outset of World War I, Winston Churchill, First Lord of the Admiralty, decided to power Britain's navy by oil from Persia as opposed to coal from Wales—a shift designed to improve the speed of the navy, but at the expense of national energy security (69–79). This founding equation between oil and military power has been in force ever since. The political character of the Middle East in particular has been shaped throughout the past century by the military and political struggle of Britain, France, the United States, and other powers to secure access to a commodity essential to the smooth operation of their economies (Harvey 177–209).

The discourse of strategic realism derives from a strict Realpolitik in matters of energy. Those who subscribe to it—and it is a discourse employed widely by government and the media alike—suspend or minimize concerns about the cumulative environmental disaster of oil and focus instead on the international tensions that will inevitably arise as countries pursue their individual energy security in an era of scarcity. What is of prime concern in strategic-realist thought is to keep economies floating in oil; at its heart is the blunt expectation that nations will protect themselves from energy disruptions by any means necessary. These means can and do take multiple forms, including economic agreements between states, the recent, largely quixotic, attempts to create energy independence by promoting the use of alternative fuels, and, of course, military intervention intended to shore up existing "power interdependencies" (Smith 188)—which, due to the US invasion of Iraq, is now erroneously, and in defiance of the facts, held to be the prime mode through which access to oil is secured. What ties these various approaches together is an element so obvious that it might appear hardly worth mentioning: strategic realism is a discourse that makes nation-states the central actors in the drama of the looming disaster of oil, actors who can and do engage in often brutal geopolitical calculations in order to secure their economic stability. While we have repeatedly been told that markets take little note of borders today, oil is clearly an exception to the rule. Its political value as a globally traded commodity is such that it apparently cannot be permitted to slosh autonomously through the markets. The state must intervene to ensure its orderly flow in the right direction.

This kind of strategic calculation conforms neatly with right-wing discourses that adopt a "might-is-right" approach to the defense of homeland, but the thinking it represents is not limited to the right. There are also liberal and left versions of strategic realism. In *Blood for Oil?*, for instance, Michael Klare explores the consequences of US dependence on foreign oil, drawing attention to the huge sums of money that are spent annually to keep access to oil open. He writes that "ultimately, the cost of oil will be measured in blood: the blood of American soldiers who die in combat, and the blood of many other casualties of oil-related violence" (183). For Klare, the proposed solution is for Americans to "adopt a new attitude toward petroleum—a conscious decision to place basic values and the good of the country ahead of immediate personal convenience" (182). The reality—a dangerous surge in energy use, in circumstances in which oil is disappearing—isn't at issue; rather, what Klare's analysis offers is a potentially less violent and more stable way of managing geopolitical realities: Americans are to be transformed into Europeans in terms of their individual energy usage. The nation remains the central actor, and the misfit between supply and demand for oil needs to be seriously considered only so that existing differentials of national power can be maintained into the indefinite future. As for the larger consequences of oil usage for the environment or for humanity as a whole, strategic realism recognizes only that oil is essential to capital and capital is essential for the status quo to continue. The potential disaster of oil in this discourse is figured as the possibility that, through mismanagement or misrecognition of geopolitical strategy, a commodity

essential to state power might no longer be available in the abundance necessary for continued economic growth.

Techno-Utopianism

A founding assumption of strategic realism is that the political future will look more or less like the present: we cannot count on new sources of energy, but must rather refine our ability to control (economically, diplomatically, or militarily) existing ones. However, there is another narrative here, one that confronts the looming end of oil by calling on science and technology to develop energy alternatives that will enable us to pass through this crisis unscathed.

This is the narrative that I am calling techno-utopianism. Government officials, environmentalists, and scientists from across the political spectrum have espoused this approach, which proposes two solutions to the end of oil: *either* scientific advances will perfect techniques for eliminating carbon emissions (exhaust scrubbers, carbon sequestering, etc.), while simultaneously enabling access to oil resources hitherto too expensive to develop (the Alberta tar sands, deep sea reserves, etc.), *or* science will create entirely new forms of energy, such as hydrogen-fuel cells for space-age automobiles. Techno-utopianism has become, like strategic realism, a ubiquitous and familiar discourse. It is already being resorted to rhetorically when politicians wish to defer difficult political decisions to some distant future, as the prime minister of Canada, Stephen Harper, did recently when he announced new "intensity-based" emissions standards: "With technological change, massive

reductions in emissions are possible... We have reason to believe that by harnessing technology we can make large-scale reductions in other types of emissions. But this will take time. It will have to be done as part of technological turnover" (Curry and Hume). Somewhat more convincingly, techno-utopianism supports the activities of those scientific and technological researchers who are working as fast as they can to steer civilization away from its blunder of hitching a complex global economy to a non-renewable dirty fuel source that is fast evaporating from the earth.

An excellent example of techno-utopianism can be found in a special issue of *Scientific American* on "Energy's Future – Beyond Carbon." The issue's subtitle announces its politics directly: "How to Power the Economy and Still Fight Global Warming." The issue presents multiple technological strategies for reducing carbon—new transportation fuels, efficient building design, clean options for coal, possibilities for nuclear power, and so on (46–114). The long-term impact of existing energy use—primarily oil—on the environment is the focus here; each article provides a potential solution based on current scientific research and technological innovation. The articles are all structured in much the same way, beginning with descriptions of the deleterious environmental effects of existing social and cultural practices, especially those in the developed world, and then moving to analyses of the failures at the level of politics to enact necessary changes to environmental laws and standards. In his introduction to the special issue, Gary Stix writes that "the slim hope for keeping atmospheric carbon below 500 ppm hinges on

aggressive programs of energy efficiency instituted by national governments" (46–49). Since such ambitious programs don't seem to be on the horizon, techno-utopians rush into the gap vacated by public policy. Scientific innovation, they assure us, can absorb and mediate all the risks that might normally unfold at the level of the political; technology will save us from ourselves. A profusion of developments from the astonishing to the relatively banal—new refrigerators that use a quarter of the energy of their 1974 counterparts, LCD computer screens that use 60 percent less than CRT monitors—are supposed to bring about not only a cleaner environment but also a soft landing for oil capital. If the various timescale charts and projections for reductions in oil usage are less than comforting, we are reminded of the following: "Deeply ingrained in the patterns of technological evolution is the substitution of cleverness for energy" (Socolow and Pacala 52). The natural historical flow of scientific discovery will resolve the energy and environmental problems we have produced for ourselves—or so it is claimed.

Faith in such technological evolution lies at the heart of not only techno-utopian solutions to the disaster of oil, but of modern imaginings of science more generally. Technology is figured as just around the corner, always just on the verge of arriving. Innovation can be hurried along, but only slightly: just-in-time technological solutions arrive when needed and not before; but they never fail to emerge. This, as we see above in Harper's comment, is certainly part of the politicians' dream, but it is equally part of the scientists' self-imaginings. For example, hydrogen is said to be waiting in the wings as the new energy source. All that

is needed is a little push to put it in its proper temporal place: "The vast potential of this new industry underscores the importance of researching, developing, and demonstrating hydrogen technologies now, so they will be ready when we need them" (Ogden 101). At the core of the notion that technological solutions will appear as and when they are needed lies another fantasy: that technological developments have in the past always appeared in the nick of time to help push modernity along. But where? And how? History offers no models whatsoever, and the dream that a coincidence between technological discovery and historic necessity will emerge now, to bring about (in this case) a change from oil capital to hydrogen capital, simply reinforces the bad utopianism of trusting in technological solutions to the looming end of oil.

Apocalyptic Environmentalism

In his editorial in *Scientific American* Gary Stix writes that "sustained marshalling of cross-border engineering and political resources over the course of a century or more to check the rise of carbon emissions makes a moon mission or a Manhattan Project appear comparatively straightforward... Maybe a miraculous new energy technology will simultaneously solve our energy and climate problems during that time, but another scenario is at least as likely: a perceived failure of Kyoto or international bickering over climate questions could foster the burning of abundant coal for electricity and synthetic fuels for transportation, both without meaningful checks on carbon emissions" (49). The third narrative of the end of oil focuses on

this scenario of eco-apocalypse. If strategic realism is largely a favorite of the right, its complement on the left is often to be found in this kind of thinking. Eco-apocalyptic theorists face the disaster of oil capitalism head on: the dire social-political-environmental consequences of inaction in regard to oil are laid out, and, because it then becomes obvious that avoiding these results would require changing everything, apocalyptic narratives and statistics are trotted out. The first two narratives remain committed to capitalism and treat the future as one in which change (new geopolitical realignments, innovations in energy use) will occur because it *has* to occur. Eco-apocalypse sees the future more grimly: it understands that fundamental social and political change is essential to address the end of oil. However, since such change is not on the horizon, or impossible to imagine, eco-apocalypse sees the future as Bosch-like—a hell on Earth, full of the tortured survivors of the present who drag themselves through a denuded landscape obscured by choking carbon-dioxide smog.

The Final Energy Crisis, edited by Andrew McKillop and Sheila Newman, is but one of many books and articles in this genre. With great care, clarity, and attention to scientific evidence about fossil-fuel depletion and environmental impacts, the volume lays out the case for the inevitability of the looming disaster. The statistics pile up to paint a truly terrifying picture: fertilizers are impossible to produce without fossil fuels; in their absence, the earth's carrying capacity for human life will necessarily fall by 50 to 60 percent; the growth of car ownership in India and China to Western levels, even with conservative estimates as to distance

traveled, will require 10 billion barrels of oil each year, "three times total oil imports of all EU countries in 2002, nearly three times the maximum possible production capacity of Saudi Arabia." Post-oil France will not be able to sustain a population of more than 20 to 25 million, Australia fewer than 1.5 million (7, 232, 265–73). And so on: everything in the book points to utter disaster as the only possible outcome of oil capitalism.

It isn't that such claims are unfounded or such scenarios unbelievable. The question is what such information is intended to accomplish. All three of the discourses I've introduced make demands of the global body politic, inviting it to generate an appropriate response to the end of the energy source on which we have built our social reality. Even while recognizing the potential traumas for human communities and for capital, strategic realism and techno-utopianism function within existing understandings of the way the world operates, and hope to maintain the status quo. Eco-apocalyptic discourse starts from the premise that disaster cannot be avoided without fundamental changes to human social life. Conditions for avoiding disaster are put forward. We must live differently, must move to a "simpler, non affluent way of life," engage in "more communal, cooperative and participatory practices," adopt "a much more collective, less individualistic social philosophy and outlook," and, of course, create "an almost totally new economic system (Trainer 280, 283, 286–87, 284 respectively).

The statistics and warnings of eco-apocalyptic discourse are intended to make us realize that without a complete change in social life, we have "no chance whatever" of avoiding future dis-

aster. *How* we are to do this is left open. Although a new social system is outlined in utopian fashion, down to what kind of houses should be on a single street and the kinds of animals that we might find in our suburbs (281), at the heart of eco-apocalyptic discourses is an acceptance that a major transformation is not likely to happen. Even if the coming disaster can be predicted and described in detail, nothing can be done to stop it. Indeed, there is a sense in which the disaster is almost welcome: the end of oil will mean that capitalism has dug its own grave, since, without oil, current configurations of capital are impossible.

Left Futures

National futures, technological futures, and apocalyptic ones. If these are the dominant discourses with respect to our oil futures, where does this leave us? We can, as a form of critical activity, point to the limits of such discourses—to the revival, for instance, of the idea of fortress nations and nationalism in strategic realism, or to the shaky historical foundations and pie-in-the-sky futurism of techno-utopianism, or to the political defeatism of eco-apocalyptic discourses. However valuable such criticisms might be, we remain in need of a discourse that can navigate its way through and around the limits of the existing narratives, while avoiding the temptation to place all our faith in science, to depend blindly on the secure comforts of nations, or to indulge in the dystopian imaginings of the End Times.

What might such an alternative discourse look like? We are certainly not lacking in exhortations and enticements for a new politics, our already shaky belief in liberal democracy having been

seriously tested by the public's abandonment of the ballot box in Western democracies, the repeated use of fictional elections to legitimize dictatorships of every stripe, and the export of "democratic" governments through military force. The time is ripe for articulations of a genuine democracy, one that no longer meekly ties its fate to the will of the liberal individual—for whom we have sacrificed almost everything in our world, including, it seems, the health and balance of the physical world itself. Constantly rising gas prices and the concomitant clear visions of a future without adequate supplies of fuel are making it evident to anyone who cares to look that the economy we have celebrated as having made many societies relatively wealthy is based not on the genius of the system called capital, but on a single, hitherto cheap and easily available commodity. But oil was never free, and now the price is going up sharply. Jacob Lund Fisker notes that "the increase in human wealth and well-being during the past few centuries is often attributed to such things as state initiatives, governmental systems and economic policies, but the real and underlying cause has been a massive increase in energy consumption... discovering and extracting fossil fuels requires little effort when resources are abundant, before their depletion. It is this cheap 'surplus energy' that has enabled classical industrial, urban and economic development" (74). A collapse in faith in its empty democracy, the disappearance of its secret source of wealth: never has oil capital been so weak and the possibilities for alternative political and economic forms so strong. Even the new head of the World Trade Organization, Pascal Lamy, has said it clearly and directly: "Capitalism cannot satisfy us."

So why hasn't the left painted a different future? Why the assumption that eco-apocalypse is unavoidable? Why meek hopes about possible transformations of capital from oil capital into hydrogen, solar, or nuclear capital; why not, instead, proposals for doing away with capital? Now is the time to be blunt: "What is most urgently needed... is not short-term technological fixes but a different paradigm of political economy. This new political economy must take our impact on the planet's environment fully and realistically into account" (Oosthoek and Gills 285). Almost twenty years after the end of the Soviet experiment, it is perhaps time to start speaking again, directly and unapologetically, about the need for what has unfortunately come to be unthinkingly rejected as an obscene concept—the planned economy, the labor of a real collective in place of a free market whose operations are no less planned for all their supposed anonymity and invisibility. Call this narrative rational futurism. The old idea of a planned economy brings to mind grainy black and white films of the Soviet era, the drama of five-year plans, and images of bar graphs made up of tractor icons displaying incredible economic growth. Planned economies of the twenty-first century would be of a different order; new technologies and scientific discoveries would shape plans for human labor and the use of fuels and other commodities in new ways, enabling societies to create meaningful, prosperous economies within ecological limits. The Soviet planners, no less than the capitalist system they opposed, still measured the success of their economies by growth—a growth also enabled by cheap fuel. Rational futurism sees economies planned not around profit or growth, but on the

real costs of fuels and other inputs, and on more aggressive redistribution of the fruits of the economy. An outline of such an economy is contained in Kim Stanley Robinson's remarkable "Science in the Capital" trilogy, especially in the final book, *Sixty Days and Counting*, in which large-scale terraforming operations become necessary to keep the Earth habitable for humanity. The idea of aggressive intervention, of forcefully reworking the environment, sounds shocking—until one realizes that we have been doing just that to the Earth all along, but entirely randomly and destructively, without any plan or idea of the larger impact of our activities.

This alternative narrative can come across as threatening or frightening. On the left, it has become an automatic reflex to reject any proposal that hints at "totality" and seems to reduce the possibility of free choice. Elsewhere, the success of thirty-five years of neoliberalism (beginning with the intervention of the Chicago School into South American economies) can be measured by the degree to which planning of any kind has come to be seen by the public as necessarily antidemocratic and an impediment to the glorious freedom of the consumer subject. One struggles to imagine even small steps, such as the possibility of any national government ever again increasing taxes, which is to say, increasing their ability to attend to collective needs. Taxation has become an evil of which everyone is frightened: perversely, we seem to fear taxes more than the end of the environment. Even if we are living its end now, we seem to prefer to cast it away into the future, into that nebulous space where somehow, things will "work out" on their own.

The immediate political challenge is of course *how* to make rational futurism into the guiding discourse of our oil futures. It is here that criticism of the other three narratives can be productive. But there must also be an insistence on the necessity of planning, for the present and for the future, in new ways. To the typical rejoinder—that is, that an idea like rational futurism is unworkable, irrational, or against human nature—the left must point to the irrationality of oil capital, its multiple failures and its historicity. There is a desperate demand for new visions that would reintroduce hope into politics and social life. The way forward is not to paint dreamy visions of a socialist future in which everything is resolved all at once by a miraculous shift in the valence of the current system. Rather, it is by emphasizing the problems and breakdowns that are appearing in the complex systems that sustain human life—systems of information, transportation, sewage, food and fuel—and addressing these with all the knowledge and insight that we have, that we will be able to begin to move people toward a view of the future that depends not on an eternal war of all against all, or the disaster of the end of nature, or even the ruthless continuation of capitalism, but on collective human ingenuity, wisdom, and hope. Rational futurism is our best chance and we should seize it now.

Bill Curry and Mark Hume (2006)
PM plans "intensity" alternative
to Kyoto
Globe and Mail, October 11

Energy's Future: Beyond Carbon (2006)
Scientific American 295.3

Jacob Lund Fisker (2005)
In McKillop with Newman
The Laws of Energy

David Harvey (2003)
The New Imperialism
Oxford: Oxford University Press

Michael Klare (2004)
*Blood and Oil: How America's Thirst for
Petrol Is Killing Us*
New York: Penguin

Pascal Lamy (2007), interviewed by
Daniel Fortin and Mathieu Magnaudeix
Capitalism Cannot Satisfy Us
Truthout
(http://www.truthout.org/docs_2006/120
707G.shtml)

Andrew McKillop with Sheila Newman,
ed. (2005)
The Final Energy Crisis
London: Pluto Press

Joan Ogden (2006)
High Hopes for Hydrogen
Scientific American 295.3

Jan Oosthoek and Barry K. Gills (2005)
Humanity at the Crossroads: The
Globalization of Environmental Crisis
Globalizations 2.3

Kim Stanley Robinson (2007)
Sixty Days and Counting
New York: Bantam

Robert H. Socolow and Stephen W.
Pacala (2006)
A Plan to Keep Carbon in Check
Scientific American 295.3

Neil Smith (2004)
The Endgame of Globalization
New York: Routledge

Gary Stix (2006)
A Climate Repair Manual
Scientific American 295.3

Ted Trainer (2005)
In McKillop with Newman
The Simpler Way

Daniel Yergin (2006)
Ensuring Energy Security
Foreign Affairs 85.2

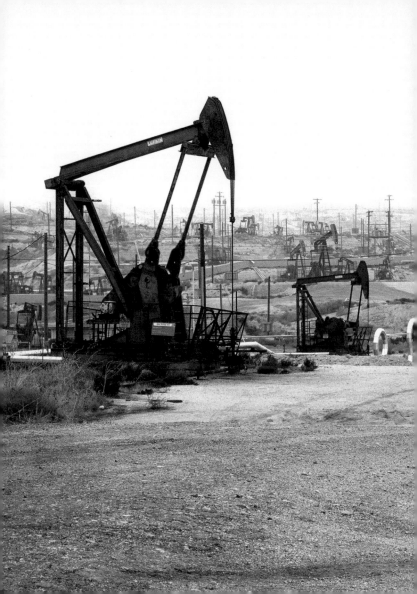

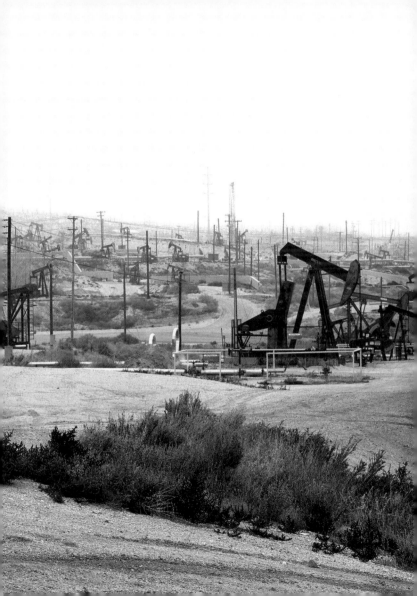

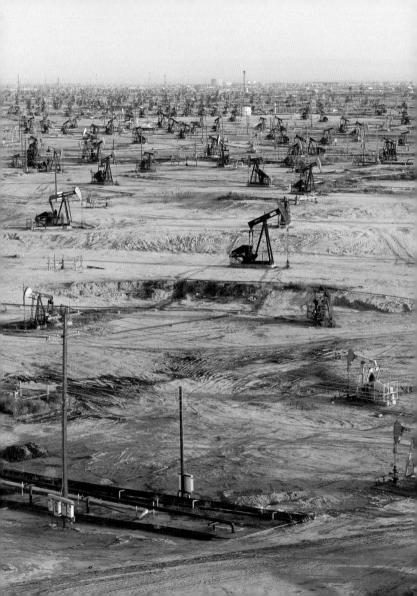

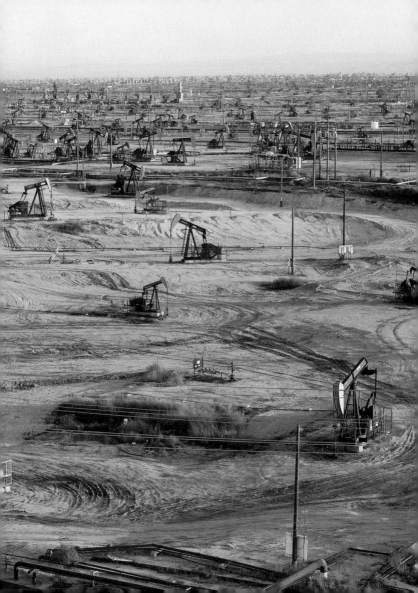

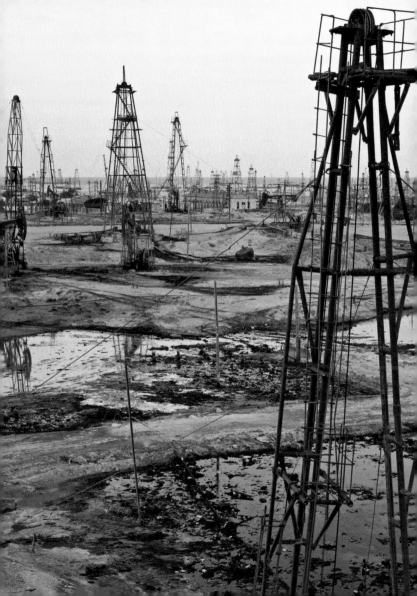

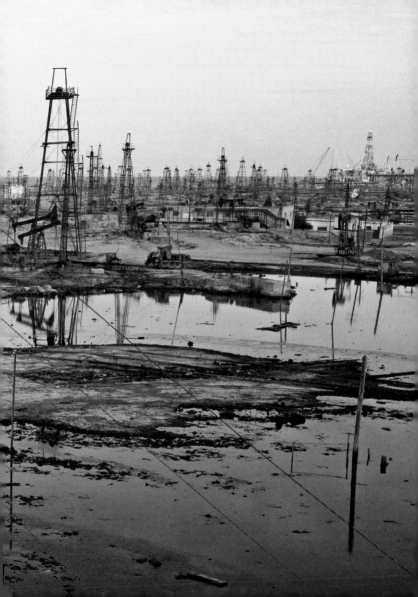

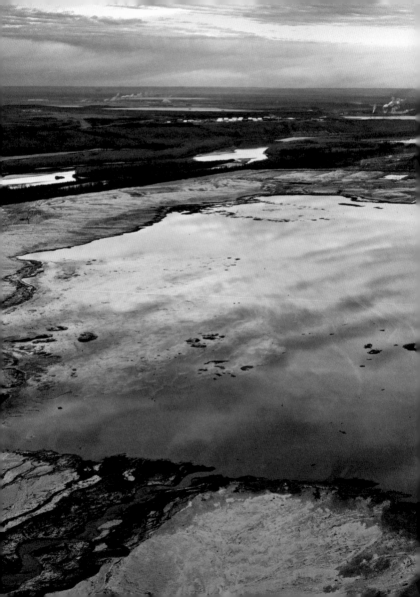

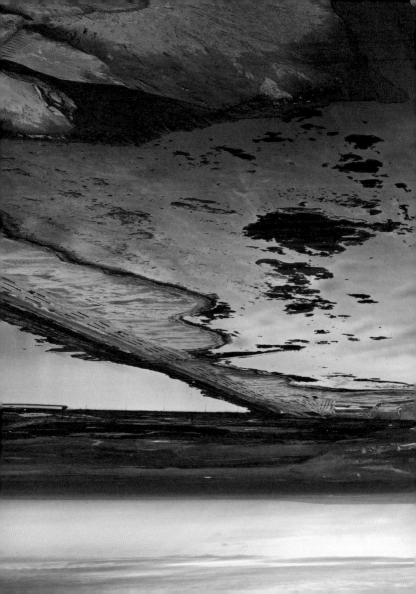

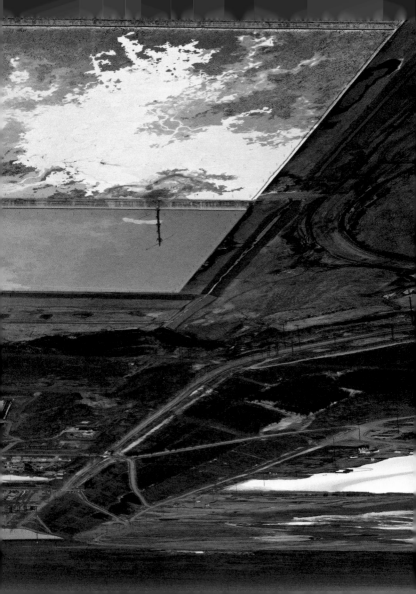

FUEL was published with
the support of:

Canada Council
for the Arts
Conseil des Arts
du Canada

ONTARIO ARTS COUNCIL
CONSEIL DES ARTS DE L'ONTARIO

DRAKE HOTEL

CLARITY

pcwf
PHOENIX COMMUNITY WORKS FOUNDATION

Editor
John Knechtel

Managing Editor
Jennifer Harris

Commissioning Editors
Jocelyne Alloucherie
Stephen Andrews
Rita Bakacs
Pierre Bélanger
Daniel Borins
Heather Cameron
Mei Chin
Mark Clamen
Karen Connelly
Roger Conover
Rebecca Duclos
Atom Egoyan
Dorothy Graham
Janna Graham
John Greyson
Chris Hardwicke
Terrance Houle
Mark Kingwell
Mark Lanctôt
Gilbert Li
Pamila Matharu
Lisa Rochon
Joseph Rosen
David Ross
Ann Elisabeth Samson
Jim Shedden
Ann Shin
Timothy Stock
Kevin Temple
Sonali Thakkar
Greg Van Alstyne
Mason White
Ger J. Z. Zielinski

Art Directors for FUEL
Claire Dawson and Fidel Peña,
Underline Studio

Copy Editor
Doris Cowan

Cover and title pages photographs
Paul Weeks

Prepress
Clarity

Legal representation
Caspar Sinnige

Contact
alphabet-city.org
director@alphabet-city.org

Thank you
Hannah Boulton
Sophie Dunsmure
Ziggi Golding
Matt Peddie
Marcus Schubert
Sonja Storey-Fleming
Matt Storus

The Appalachian Basin Pennsylvania
Grade Petroleum Crude Oil for the pho-
tography in this book was donated by
ONTA Inc.

Upcoming issues
Fall 2009
no. 14: WATER

Fall 2010
no. 15: AIR

FUEL

Lateral Architecture is the Toronto-based design studio of Lola Sheppard and Mason White.

George Osodi is an award winning Nigerian photographer.

Maya Przybylski applies her training in architecture and computer science to the investigation of complex systems.

Imre Szeman lives and teaches in Hamilton, Ontario.

Candice Tarnowski is a Canadian artist dividing her time between the North and South Poles. theseaoftea.blogspot.com

Geoffrey Thün is a Toronto-based designer, urbanist, and professor of architecture.

Kathy Velikov is an architect and professor of architecture living in Toronto.

Paul Weeks is a Toronto based commercial photographer.

Susannah Wesley is an independent curator and artist living in Montreal.

Mason White is a partner in Lateral Architecture and teaches at the University of Toronto.

CONTRIBUTORS

Edward Burtynsky photographs the world's most spectacular expressions of industrialized landscape.

Robin Collyer is a Canadian sculptor.

Kelly Doran is an architectural intern living in Canada.

Sara Graham is a visual artist and the founder of Citymovement, a multidisciplinary art and design enterprise. www.citymovement.ca

Chris Hardwicke is an urbanist and associate at Sweeny Sterling Finlayson &Co Architects.

Jennifer Harris teaches English at Mount Allison University.

Romuald Hazoumé is a Beninese artist represented by October Gallery, London.

Vid Ingelevics is a visual artist, independent curator and wood stacker living in Toronto. www.web.net/artinfact

Robert Kirkbride, new yorker, is an architectural designer and an associate professor of product design at Parsons.

John Knechtel founded Alphabet City in 1991.

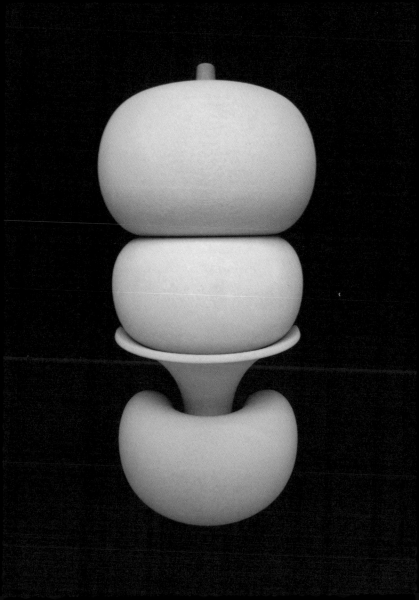

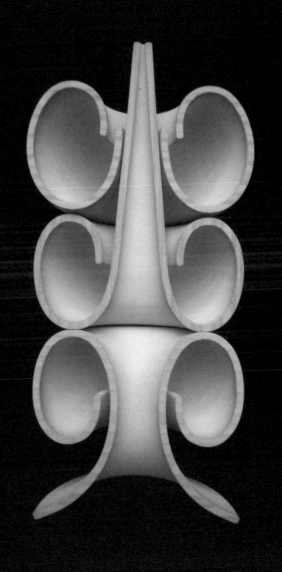

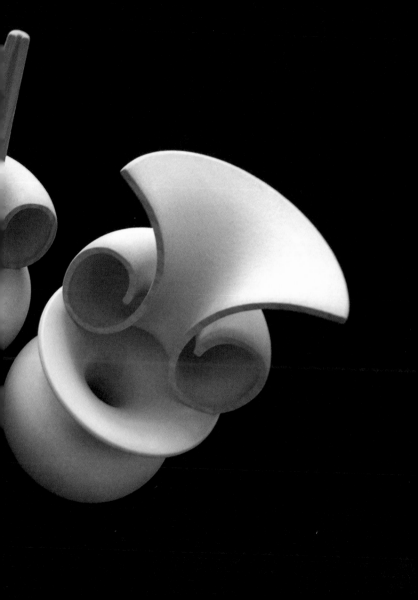

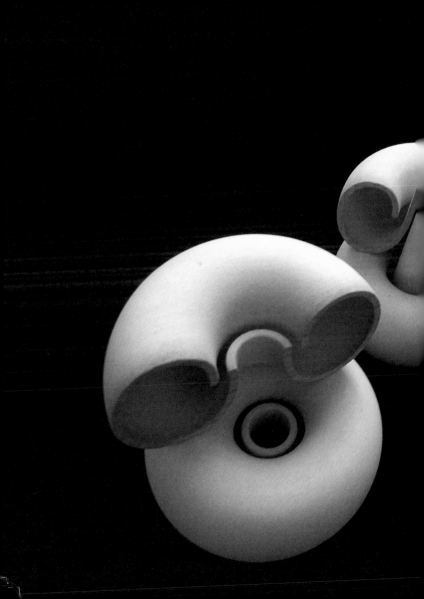

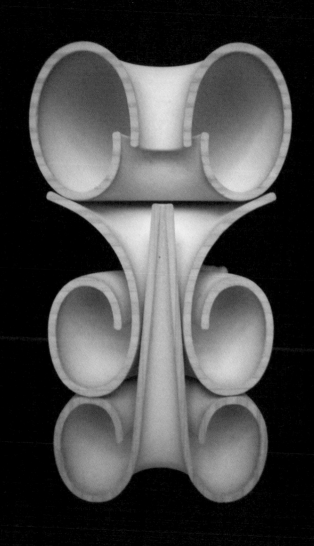

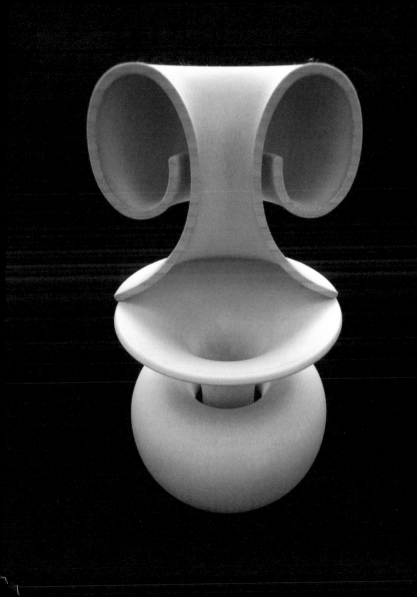

exterior, entropy and emergence. Being open-ended rather than self-contained, they invite imaginative recombination and are akin to, yet different from, such enigmatic creatures as the Möbius strip or Klein bottle. *Culobocca*'s closest living relatives are black holes, quasars, and the ouroboros, that obsessive beast ever chasing its tail, though it may be more accurate to say that *Culobocca*'s mouth comes out of its tail rather than around it. This is not to say, however, that it is talking out of its ass.

7.75" x 6" diameter
Plaster, water, epoxy
Z-Corp Spectrum Z510 3D printer
Special thanks to Veronica Choi
Photos: Robert Kirkbride

Wouldn't it be nice if problems were as efficient and simple as the models and metaphors we invent to understand them? As a placeholder for the perfect fuel, *Culobocca* is a nod to the alpha and omega of the body, and our navel-gazing tendency as a species to consider ourselves as universal be-all and end-all. The form originated some years ago as a continuous line drawing of an object that could pass through itself, as a vision for how design and research might be mutually replenishing. The sketch evolved into a cryptic map for living, and variations soon followed, including *Hornblower* and *Longnose*.

Physically, each member of the *Culobocca* family is composed of a single, continuous surface that is simultaneously interior and

what we wanted. I feel like we have tapped into a whole new aspect of this city, a place that is ours to enjoy and shape around us. The spirit of the city and of those who inhabit it should intertwine and grow around each other. [Canard Development Group] takes that concept to a whole different level.

Annie Chung, Restaurant Owner: I have a completely symbiotic relationship with the building that my home is going to be attached to. It will benefit from my presence, and I feel completely comfortable in this space. We are all excited about the project. I think more relationships appearing around the city will really change the face of Toronto as a whole, as well as the concept of urban living. It is really a new sense of community, and is really what we need for the future.

Testimonials

Alan Markfield, Web Developer: The whole idea seemed very implausible to me, but I was intrigued, so I got started. From the very beginning the people at Canard blew me away with the strategies they had come up with to make my ideas reality. I wanted a view of the city with perfect northern light, and they made it happen! I wanted to reach my home by elevator, and I got it. I wanted a place for a rooftop garden, and there it was...I felt a little bit like they had a magic wand

Cathy Shear, Artist: I am actually living my dream. I chose the exact place in the city that I wanted as my home, and then got to design a house for that location! What other design group gives you that kind of freedom? And on top of that, they were the most capable and helpful people I've ever worked with. They had solutions for every question I had.

Tatyana and Surendra Mahara, Lawyer and Art Consultant: We couldn't be happier with our home. It's great as well to be on the cutting edge of home design. Our friends can't stop talking about it!

Thierry Malik, Freelance Journalist and Writer: A Canard home worked so well for me and my family. We thought at first that there was no way it could be within our budget, but Canard worked with us to design something that met our needs, and to find a location that was feasible. They build such great relationships with their customers, and really seemed to care that we were getting

- Distance between the factory and site location affects transportation costs
- Security considerations of host building

If you require financing for your project, you will need to obtain pre-approval from a modular-friendly lender. If you do not have a lender, Canard would be happy to introduce you to lenders who are competitive, informed, and modular-friendly.

Step 6: Building your dreams

Once the permits and financing are approved, we begin the next exciting step to ownership. The plans for your A.I.R. home will be sent to our factory to be built and inflated. During this time, any needed site preparations are completed in advance of the positioning of your new A.I.R. unit. Once our site contractor has prepared the site and the modules have been built, Canard will arrange to have your new A.I.R home delivered to your site and attached to the existing structure. Our module home travels by truck or helicopter to the location and requires a crane or other technology to install. Once attached, your new home is ready for moving in!

Step 7: Celebrating your new Canard home

Get out your champagne glass and prepare to enjoy your new A.I.R. home!

6. The appropriate delivery method and positioning of your home. A delivery assessment meeting will be scheduled and will last about one hour. A written report, schematic design documents, and photographs will be emailed within two weeks of your site visit.

Step 4: *What does "home" feel like?*

This is your opportunity to work with our Interior Mood consultants to decide what unit would best suit your needs and create your ideal living environment. Canard will send you an Ambiance Package that will include a catalogue of materials and finishes to choose from in personalizing your A.I.R. home and should be reviewed before your meeting. During your design meeting, any modifications to your unit will be discussed. If you would like assistance furnishing your new home, please let us know.

Step 5: *Realizing hopes*

Your total project cost will depend on many factors unique to your A.I.R. home and your host site. Based on the working budget that will be updated throughout the process, Canard will meet with you to confirm the total final cost of your A.I.R. home from consultation through construction and installation. We work closely with clients to find the best solution for their site and each project is carefully considered. Common circumstances that can affect the feasibility and costs of your A.I.R. home include:

• Height of structure that your home will be attached to
• Reinforcement of existing structure, if needed

Step 3: **Which location is right for you?**

Potential locations for your A.I.R. home are endless and limited only by your imagination. Access to surrounding amenities, commuting time to work, height of the host structure, and the orientation of your unit are all things to consider when making your decision about where to put your A.I.R. home. There are many steps in locating the perfect site, and at Canard we work with you to discover the ideal location. The first step in finding your location is a consultation with our siting specialist. A detailed evaluation will be created and our team will research the city to find the ideal location. Once your location preferences and options have been developed, you will make an initial non-refundable down payment of $10,000 that will be applied against the final cost of your new home. Canard will then work with our partners to secure the location. In the case that you already have an area or particular structure in mind, our siting specialist will work with our partners to obtain access to your desired site.

Once a site has been secured, the next step is to schedule a site visit. Because site access is critical for every A.I.R. home, we will set up a site visit to develop an appropriate delivery and installation strategy. The delivery assessment includes a site visit by the architects and siting specialist, who will determine the following:

1. Which A.I.R. unit will work on your site.
2. The optimum sun exposure assessed through a solar study.
3. Placement of the A.I.R. unit based on sound and wind exposure.
4. Which custom support system is possible with the site.
5. Where the customized access point will be located.

Steps to Ownership of Your New A.I.R. Home

Canard Development Group's full-service architectural design team specializes in innovative modular technology. We have developed an efficient *Seven Steps to Ownership* process to ensure that you are happy with your new home. This process provides clients with an extensive lifestyle-compatibility analysis and site consultation to locate your ideal living space.

Step 1: Are you ready to own an A.I.R. home?

Are you ready to own an A.I.R. home? A.I.R. offers a unique living option and we want to make sure it is compatible with your lifestyle. An initial meeting, approximately one hour in duration, will be set up with an A.I.R. consultant to discuss the intricacies of the A.I.R. lifestyle. If Canard feels that both parties are well matched, then a second meeting for a lifestyle analysis will be scheduled.

Step 2: Who are you?

The lifestyle analysis will take about an hour and a half and is a comprehensive exploration of your lifestyle patterns, personal preferences, daily routines, likes and dislikes, and any specific needs or requirements you may have. The Lifestyle Analyzer will compile the resulting data and email a written report of the findings to you within one week of your visit. This report will offer a selection of housing options and locations that will meet your lifestyle needs and desires.

Structure
/ Light gauge steel structure
/ Inflated ETFE (ethylene tetrafluoroethylene) panels act as a thermal buffer for integrated interior radiant heating and cooling
/ Utility core mechanical system concealed on exterior wall
/ Rooftop urban crop garden aids interior air filtration
/ Green roof (garden) provides additional layer of insulation and reduces cooling costs
/ Rooftop solar panel
/ A.I.R. lift floor system™
/ Each basic unit is 8m x 3.5m
/ Each basic unit is 450 square feet including mezzanine

Ceiling
/ 19 feet in common area
/ 9 feet in mezzanine

Principal Rooms
/ Each room has sensory lighting and uses Nemalux LED
/ Low energy electronics
/ Pre-wired for high definition cable TV and telephone

Kitchen
/ Top-of-the-line energy efficient Fisher and Paykel appliances: refrigerator, cooktop, convection, dishwasher, and microwave

Bathroom
/ Single lever chrome faucets (reduced flow rate of 9.5 liters per minute)
/ Grohe shower head temperature controlled and pressure balance (reduced flow rate of 9.5 liters per minute and with faucet restrictor a reduced flow rate of 5.7 liters per minute)
/ Dual flush toilet with 3 or 4 liter flush option

Laundry
/ Stack front loading laundry and dryer (uses 34 liters of water per load and 135 kwh of energy per year)

Balcony
/ Retractable glass wall
/ Indoor/outdoor city view balcony

State-of-the-Art Technology
/ Emergency smoke, heat and panel deflation detectors
/ Linksys wireless G broadband router creates a wireless network to share with high speed connections (free internet)
/ Heat recovery ventilator (expels stale indoor air and gaseous pollutants and exchanges heat with warmed/cooled revitalized outdoor filtered air)
/ Key card access
/ Integrated photovoltaic energy glass wall (can produce 470 kwh energy per year)
/ Energy metering control unit—the in-home customer information panel reduces waste
/ Non-essential energy usage control panel informs consumers of their energy consumption on and off the grid
/ Drain water energy recovering system

Features

Using less, enjoying more. A.I.R.'s unique
state-of-the-art technology features
maximize overall household efficiency
and are environmentally sustainable.

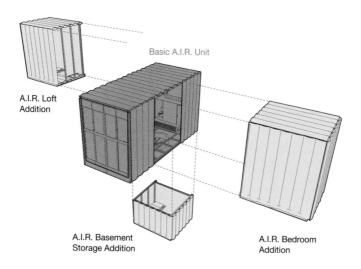

Basic A.I.R. Unit

A.I.R. Loft
Addition

A.I.R. Basement
Storage Addition

A.I.R. Bedroom
Addition

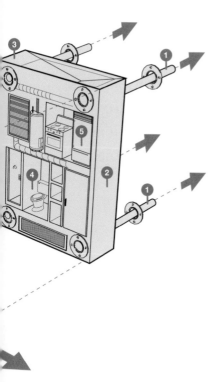

01 Water and Electrical Tap
02 Power Cell and Utility Core
03 Rainwater Collector
04 Wet Zone: Washroom
05 Wet Zone: Kitchen
06 Light Gauge Steel Frame
07 A.I.R. Lift Floor System
08 ETFE (Ethylene
 Tetrafluoroethylene)
09 Urban Crop Garden
10 Solar Panels
11 Composting
12 A.I.R. Unit Host Cable
13 Retractable Glass Wall
14 City View Balcony

A.I.R. Using less, enjoying more

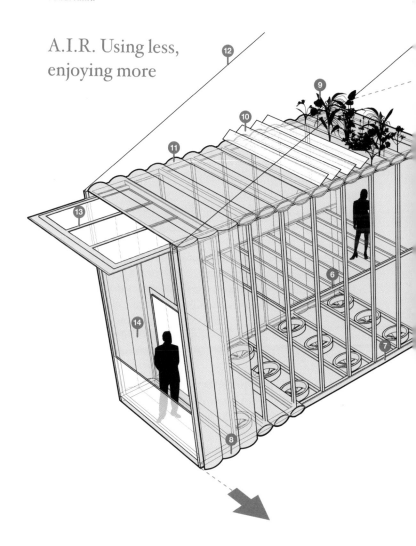

A.I.R. units can be stacked or linked together to provide larger configuration options; you simply select the number of units you would like.

A.I.R. uses state-of-the-art construction materials and technologies that maximize overall household efficiency and are environmentally sustainable. Each basic unit is designed to be 75 percent off-grid, which means that for nine months out of each year, A.I.R. can generate and store enough energy to independently supply the unit and its occupants with electricity, air, and water. The remaining 25 percent is tapped from the existing infrastructure of the host site.

We have researched and developed the latest in construction techniques and building processes in forming A.I.R. Each unit is composed of a light-gauge steel structure, ETFE panels, and glass. The light-gauge steel allows the structure to be as light as possible, maximizing its possible configurations. The ETFE panels operate like inflated pillows, allowing the project to remain lightweight while simultaneously providing insulation.

A basic price for an A.I.R. unit located on a host site that is under six stories is between $200/sf and $275/sf. A unit for a location above six stories is priced between $275/sf and $400/sf. The total cost to install your Canard home will vary depending on which design you choose, the custom support system, and your site location. Installation costs start at $3,500 per unit, but can vary according to the height and other intricacies of your site.

We know that selecting an A.I.R. home is not only a smart choice, but one that will furnish you with the lifestyle you have always wanted.

Project

A.I.R. is an exciting new freehold residential unit from Canard Development Group offering spectacular value and breathtaking views, and constructed to BuiltGreen™ specifications. A.I.R. represents cutting-edge technology in residential planning—a portable unit that can fit into any community and be attached to any building. This revolutionary housing unit permits homebuyers to select not only their location, but also if their A.I.R. unit will be hung, cantilevered, suspended, floated, assembled on, assembled in, or extended from the host site. Depending on your chosen site,

homebuyers is a hallmark of every Canard project. Inside and out and from beginning to end, we create distinctive living spaces that work for you, for the environment, and for your community.

Working with an eye to unique alternatives, Canard is committed to environmentally responsible design. Utilizing BuiltGreen™ technologies, we develop homes that enhance the urban landscape and offer energy efficiencies to our homeowners. Our focus on design innovation is a cornerstone of all of our work —from architecture to interior design to the construction process. This dedication and commitment to quality defines who we are and why we succeed. And, every component of every Canard project is 100 percent recyclable, reusable, or biodegradable.

Come and visit us today and experience the difference with Canard.

Canard Development Group

www.canarddevelopmentgroup.com

Vision

Canard Development Group is a revolutionary planning and urban design group that creatively links social responsibility, sustainable construction practices, and innovative design strategies. We seek to redefine traditional uses of space, materials, and technology to develop exceptional projects that meet the housing needs and interests of today's forward-thinking homebuyer. Our alternative living spaces lead the way toward the positive change that conscientious city-dwellers want in a constantly changing urban environment.

Innovative design solutions are the essence of our company. Established in 2000, Canard Development Group provides today's homebuyer with truly unique living solutions. Canard is at the urban center of pioneering development and redevelopment projects around the globe. We have extensive experience in shaping and enhancing urban spaces using our expertise in construction, land planning, urban development, and cutting-edge design. Canard deploys the tools and techniques of the future for the benefit of the citizens of today. Our portfolio includes commercial and residential projects such as the Panoramic Viewpoints, the Bennett Building, Portable Pilchard Saloon, Sunbuckle Commons, Frothblower Biosphere, and Snuffclipper bird sanctuary.

Canard has a reputation for creating ground-breaking homes in highly sought-after locations. Canard is also known for providing public and private clients with focused and responsive customer service. Attention to detail in design and fabrication as well as in our relationships with current and prospective

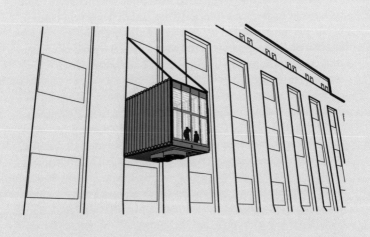

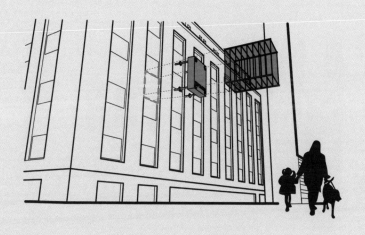

A NEW
CONCEPT FOR
LIVING

A.L.

SARA GRAHAM AND LATERAL ARCHITECTURE

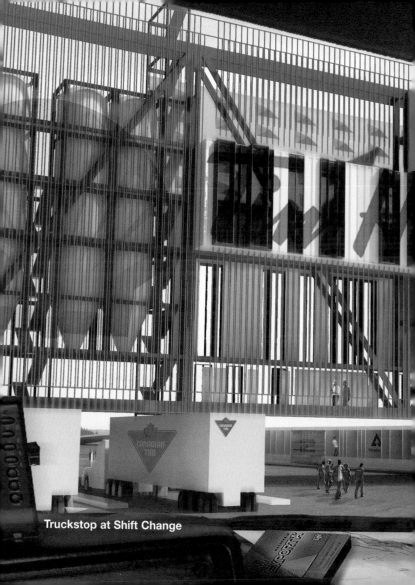

Truckstop at Shift Change

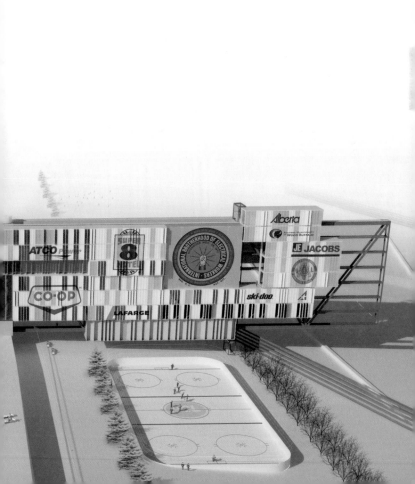

Truckstop

The Tar Sands' supply line is Highway
63: all industrial inputs (labor, heavy
equipment, pipe, etc.) arrive by truck.
The truckstop is the locus of activity–this
town-in-a-building mounts the constituent
parts of a typical work camp onto a steel
skid frame. With a curling rink on the
fourth floor, union halls on the third, and
work camps on all levels, the truckstop
is an elevated town. The truckstop's
structure and energy infrastructure will
expand to provide for influxes of workers
while maintaining a minimal footprint
on the land.

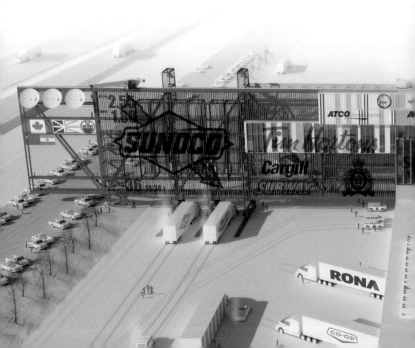

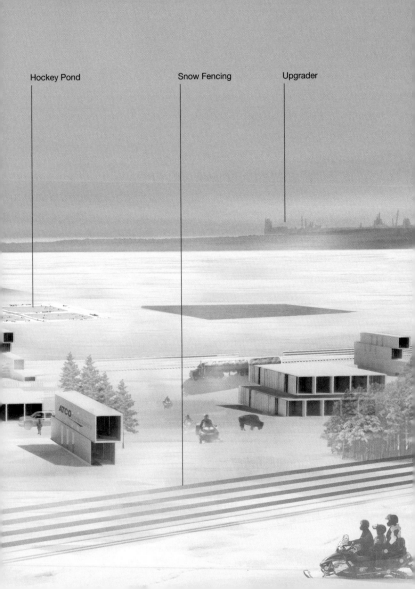

Hockey Pond

Snow Fencing

Upgrader

ATCO

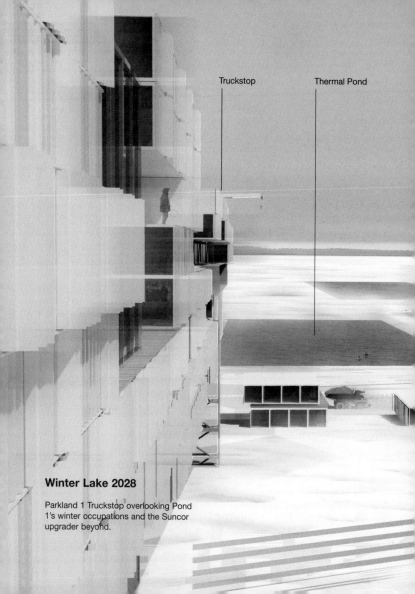

Truckstop

Thermal Pond

Winter Lake 2028

Parkland 1 Truckstop overlooking Pond
1's winter occupations and the Suncor
upgrader beyond.

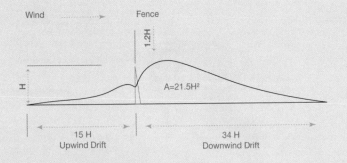

4 m H = 60 m + 136 m = 196 m fence spacing

Optimal spacing of snow fences

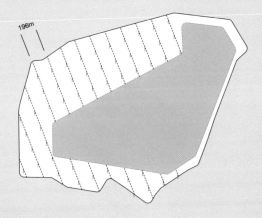

196m

Snow Fencing and Monitoring

A permanent snow fence infrastructure is spiked into the landscape at calibrated intervals to ensure the Parkland's hydrological survival. The fencing also demarcates zones for industrial occupation and settlement.

Wind Speed (km/h) 9.7
Prevailing Direction East-North-East
Snowfall (cm) 155.8

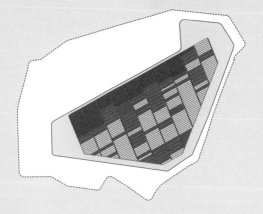

Anchored Pontoon Frame

Remediation Reed Beds

Cranberry Bog

The Pond

Suncor uses the Clark hot water process
to extract bitumen from oil sand. The
tailings from this process are a slurry of
water, clay, sand, and residual bitumen.
This slurry is stored in ponds, where
the clay/water mixture forms a stable
suspension. This industrial pool-liner
ensures the Pond's survival, allowing it
to morph from toxic to productive.

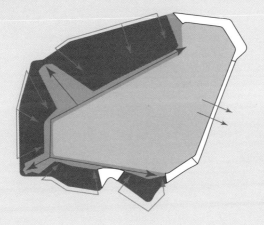

Wetland Rim

Fallow

Planted Rim

The Wild

Fens and trees to be (trans)planted on
edges and encouraged to expand via
constructed corridors. "The Wild's" initial
planting will be left to take on a natural
or mutant development in response to
future industrial activities.

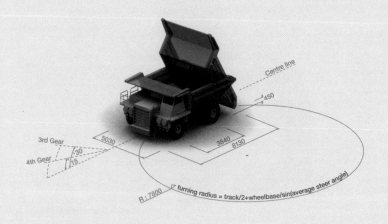

Centre line

450

3rd Gear

4th Gear

30

15

5030

3840

8130

R : 7800

▽ turning radius = track/2+wheelbase/sin(average steer angle)

It takes 1 tonne of sand to produce
1 barrel of oil. At 2007 production
levels, that means 260,000 tonnes of
sand per day, or some 100,000,000
tonnes per year.

Industrial Landscaping

Constructing the landscape from the ground up permits slopes, soils, infrastructures, and hydrological controls to be embedded with precision. Each year one pond or pit will be filled with the sand produced by mining activity, individually programmed and designed to create optimal conditions for the selected production for that pit.

Targeted Fill

Ponds and pits will be filled initially with the volume of soil generated by the plant annually. Each pond/pit will maintain hydrological independence and thus a body of water for industrial usages.

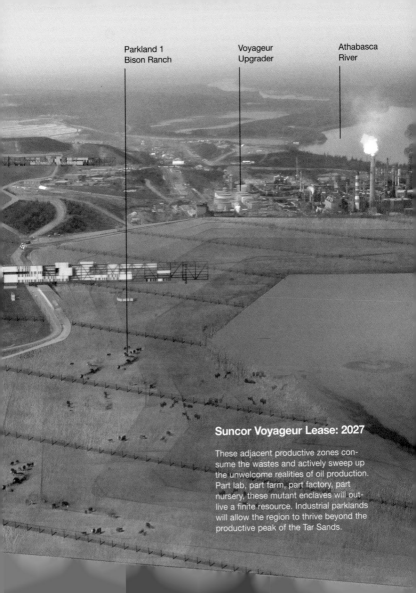

Parkland 1
Bison Ranch

Voyageur
Upgrader

Athabasca
River

Suncor Voyageur Lease: 2027

These adjacent productive zones con-
sume the wastes and actively sweep up
the unwelcome realities of oil production.
Part lab, part farm, part factory, part
nursery, these mutant enclaves will out-
live a finite resource. Industrial parklands
will allow the region to thrive beyond the
productive peak of the Tar Sands.

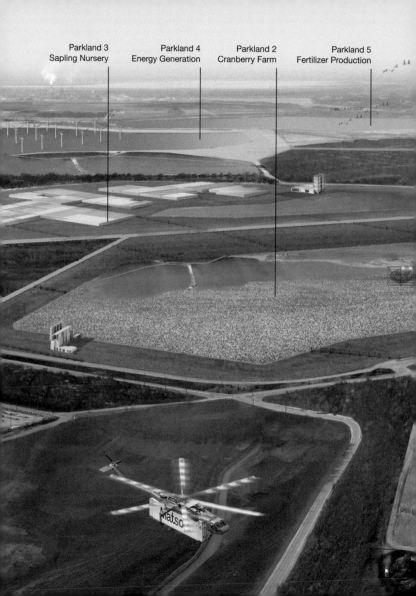

Parkland 3
Sapling Nursery

Parkland 4
Energy Generation

Parkland 2
Cranberry Farm

Parkland 5
Fertilizer Production

**Exhausted
2060**

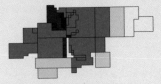

**Post peak
2075**

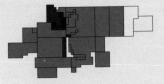

200,000
Barrels Per Day

60 km²
Industrial Parklands

450 km²
Productive Wilds

0
Barrels Per Day

60 km²
Industrial Parklands

640 km²
Productive Wilds

Augmented Lease Evolution

The processes that manufacture this land-scape could be designed to yield radically different results. A replacement strategy that accounts for ongoing oil activities while encouraging emergent, quasi-parasitic, non-oil industries to take hold is possible. Instead of becoming a simulation of nature the lease can transform itself into a heterogeneous network of industrial parklands and productive wilds.

In the proposed evolution of the Suncor leaselands outlined here, the production of oil will be offset by the production of other staples: lumber, glass, cranberries, and bison.

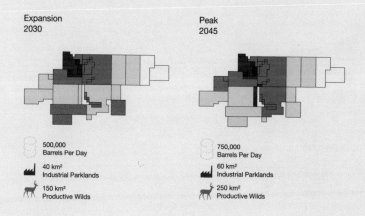

Expansion
2030

500,000
Barrels Per Day

40 km²
Industrial Parklands

150 km²
Productive Wilds

Peak
2045

750,000
Barrels Per Day

60 km²
Industrial Parklands

250 km²
Productive Wilds

■ Upgrading Facilities

■ Active Mining

■ Clear-cutting

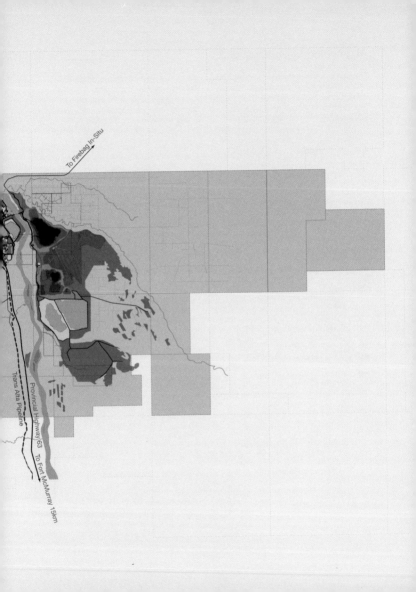

Suncor Lease

Suncor has been converting tar sands
into crude for three decades. The
Suncor lease's 700 square kilometers is
a mix of boreal forest, clear-cuts, dried
muskeg, open-pit mines, water reser-
voirs, sand piles, tank farms, upgraders,
pipelines, gravel roads, and tailings
ponds. In sixty years the entire lease will
be excavated, replaced, and replanted,
transforming the watershed ecology into
a landscape of quarantined ponds and
homogeneous plantings.

Clear-cut

Muskeg Dredging

Open Pit Mine

Pond

Pile

- - - Pipeline

Highway

MacKenzie River

0 5km

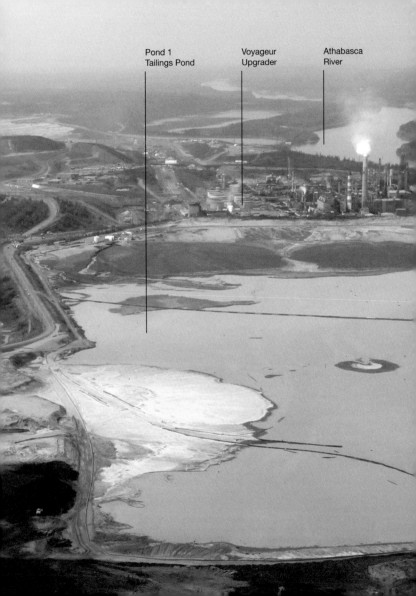

Pond 1
Tailings Pond

Voyageur
Upgrader

Athabasca
River

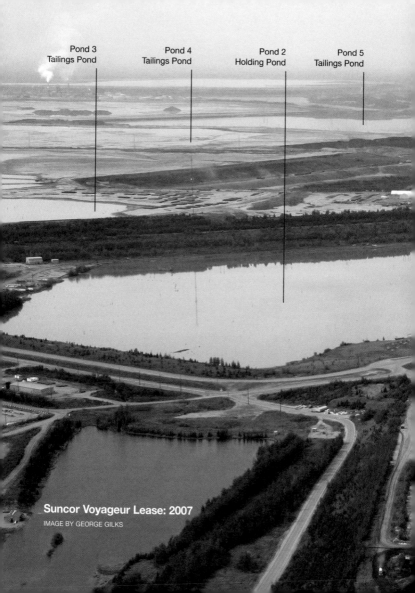

Pond 3
Tailings Pond

Pond 4
Tailings Pond

Pond 2
Holding Pond

Pond 5
Tailings Pond

Suncor Voyageur Lease: 2007
IMAGE BY GEORGE GILKS

Tar Sands Growth 2007–2015

Syncrude

Suncor Energy

Shell

Canadian Natural

Petro-Canada

Total

ExxonMobil

EnCana

Husky

Legend:
- 50,000 barrels
- 1,000 operators
- 2007 level
- 2007-2015 growth

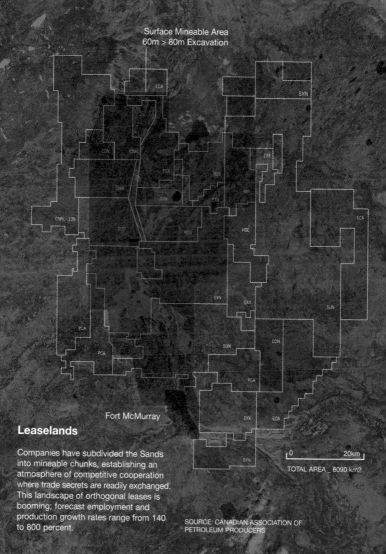

Surface Mineable Area
60m > 80m Excavation

ECA

SYN

CON CNR

EXX

PCA

IOS

CNR

IMB

SYN EXX

CNRL - 139

IOT

ROS

HSE

ECA

SYN EXX

SUN

PCA

SUN CDN

PCA

Fort McMurray

EXX ECA

Leaselands

Companies have subdivided the Sands
into mineable chunks, establishing an
atmosphere of competitive cooperation
where trade secrets are readily exchanged.
This landscape of orthogonal leases is
booming; forecast employment and
production growth rates range from 140
to 800 percent.

SYN

0 20km

TOTAL AREA _ 6090 km2

SOURCE: CANADIAN ASSOCIATION OF
PETROLEUM PRODUCERS

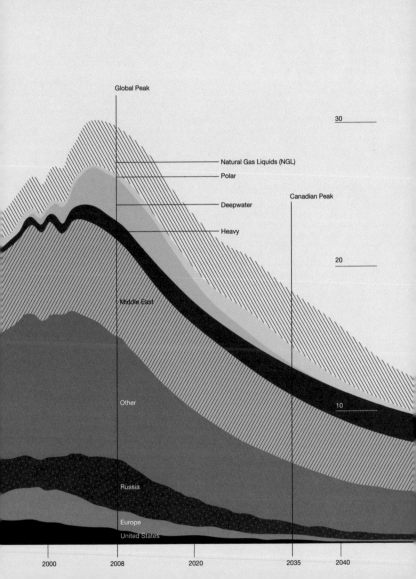

Global Peak

30 _____

Natural Gas Liquids (NGL)

Polar

Canadian Peak

Deepwater

Heavy

20 _____

Middle East

Other

10 _____

Russia

Europe

United States

2000 2008 2020 2035 2040

Peak Oil

The Athabasca Tar Sands contain 13 percent of the world's known oil reserves, second only to those of Saudi Arabia. Canada's forecast peak in 2035 comes after that of every other oil-producing nation; Tar Sands production will accelerate against a backdrop of global decline. A resource in the infancy of its development, the Tar Sands' estimated fifty-plus-year year lifespan has focused foreign capital on Alberta.

PEAK OIL: GLOBAL OIL PRODUCTION IN GIGA BARRELS PER ANNUM

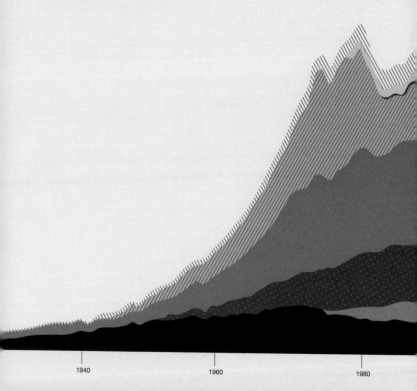

1940 1960 1980

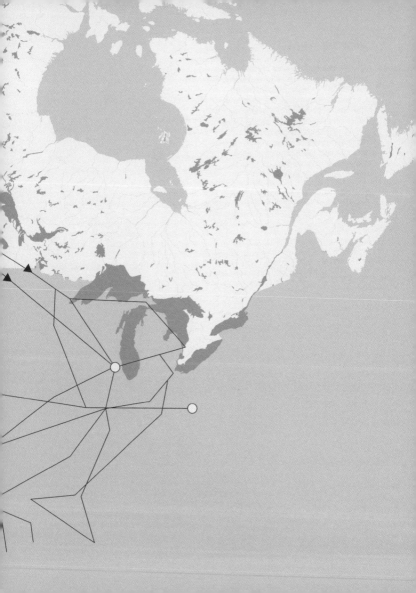

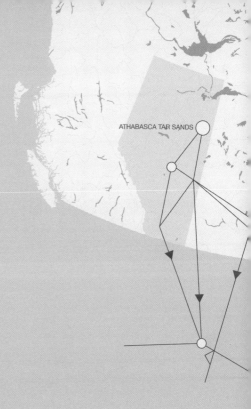

ATHABASCA TAR SANDS

North American
Pipeline Network

The American pipeline network now
extends into Canadian territory, linking
southern markets to undeveloped north-
ern resources. Running perpendicular
to the east-west Canadian Pacific
Railway and Trans-Canada highway, the
Alliance Interconnect from Edmonton
to Chicago has reoriented the petroleum
economy to the US. By 2030, this oily
artery will pump 5 million barrels of oil a
day into American refineries.

Tar Sands Pond 2037: Cranberry farming and tree nurseries occupying exhausted mining pit lakes.

Northern Alberta's Athabasca Tar Sands development juggernaut has passed the point of no return. The world's second-largest remaining reserve of oil, the Tar Sands are being scraped from the land, cooked, refined, and piped to the United States–and nothing is going to stop it. Aside from oil, the products of this industrial activity are the sterile, homogeneous, quarantined, and supposedly remediated landscapes left behind. Altering the processes by which these devastated landscapes are manufactured could generate a dramatically different topography. Configuring the landscape to provide for other forms of industrial production will mitigate oil's activities and provide for a post-peak future.

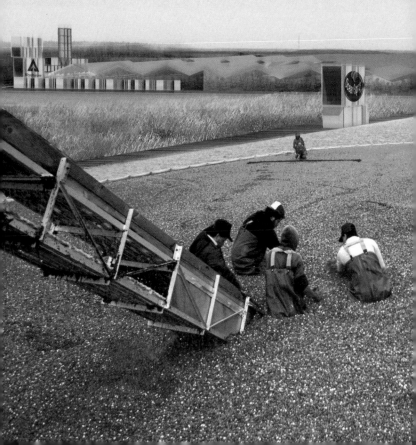

sweater or a blanket: we can burrow under the cover and create our own imaginings for the space. It provides a place for respite, rehabilitation, and the possibility of seeing this world as a place where we, as individuals, have influence and agency.

Blankety Blank provides an ecological perspective on landscape and community. It describes the persistence of life in the face of obliteration, and the importance of relationships — between the artist and the viewer, the viewers and their community — in maintaining this dynamic. The work provides a model and a metaphor for our actions and relations within the real world. It supplies the space for reflection, the jolt of realization, and the fuel to act.

— *Susannah Wesley*

Similarly, the landscape of *Blankety Blank* appears desolate and spent, while the fabric of its topography hides mounds of sleeping histories and memories—remnants of lives embrace one another in soft eternal rest. Whereas the above-ground exists like a limbo world: communication is happening but we cannot hear it, communities exist but we are in-between them, fires were actively burning but now the land is black and barren.

Blankety Blank exists as a reflective and evocative record, generating contemplation about our tenuous relationship with our physical world and simultaneously our deep connection to it. The work reinforces that we not only exist within the world, using it for our own means, but that we are made of it, sustained by it, and eventually in death we become a part of it. It challenges us to consider how we are choosing to spend our own individual and collective energies. In tandem, the work also asks us to question how we are harnessing the natural physical resources around us. Within this emptied landscape we can imaginatively impose our own narratives of the past, present, and future. Landscape is an inherently subjective construction, but the paradoxes and ambiguities within this work invite additional slippages and flexibility, heightening our consciousness of our own subjectivity. We, the viewer, have the power to fill in the blank with whatever text we would like. With this realization, the pedagogical nature of the work's installation—as a geological cross-section—is abolished. Fears of misreading the work are nullified because the artist has openly invited us to impose on her creation. This results in an abstract and comforting moment of interaction between the artist and the viewer. It is as if the artist herself has handed us a

Charred and black, the landscape invokes the aftereffects of wild land fires, agricultural burnings, or even the geography of Alberta's oil fields. However, rather than harboring the black molasses-like lube of oil beneath its plane, the energy below this surface is much more intimate and varied. Scarves, bonnets, mittens, sheets, towels, linens, ribbons, and rags lie snugly dormant, pressed together, unreachable but not invisible. Pushed down underneath the ground, the physical remnants of the place have been lying fallow, storing fuel and waiting.

There are communities preserved in the buried remnants: bonnets signal babies, a mitten signals a child, blankets conjure up a caregiver. The small pockets of color embody a presence and social vitality. But the items themselves also embody human energy; handmade, they perform as sources of comfort, protecting people and providing warmth. They represent an alternative form of fuel, ensuring survival through their own physicality and the possibility of collective memory they represent.

As such, *Blankety Blank* acts as a holding place. Not only do the submerged layers hold communal energy, but the black surface ground's reference to fire and controlled agricultural burning also signals a human adjustment for the production of fuel, refreshing the soil and making way for the regeneration of crops. Even the decrepit telephone lines represent a form of social energy. However, despite all of these indications of hope and possibility, the materialization of renewal seems fragile, illusory, and ambiguous.

The world of *Blankety Blank* is perforated with ambiguity and paradox. Those slumbering underneath blankets may appear still, almost dead, yet their minds are alive with active dreams.

Packed with energy, Candice Tarnowski's installation *Blankety Blank* presents a landscape on hold. Sliced and trapped behind glass, it sits like a geological specimen, raw, crisp, and precise. Layers of textiles press up against one another like tectonic plates, building to the surface, forming rolling beds of earth. The landscape is barren and bleak. It is formidable. It seems uninhabitable. The only sign of life is a delicate string of severed telephone wires, telling us that communities do exist—but elsewhere, not here.

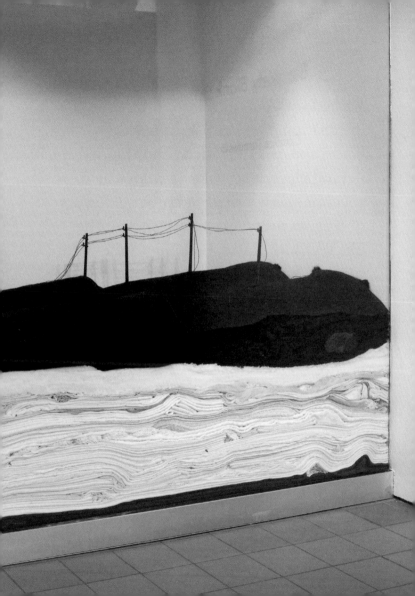

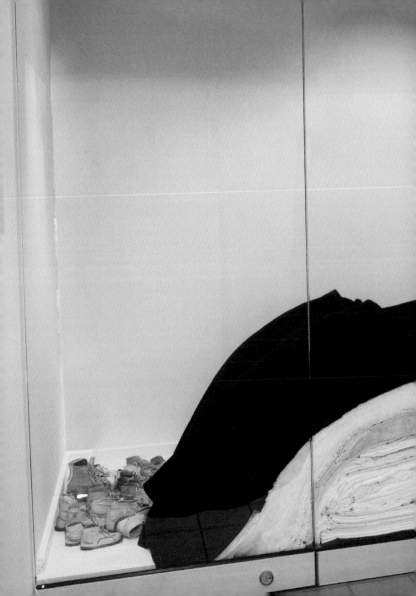

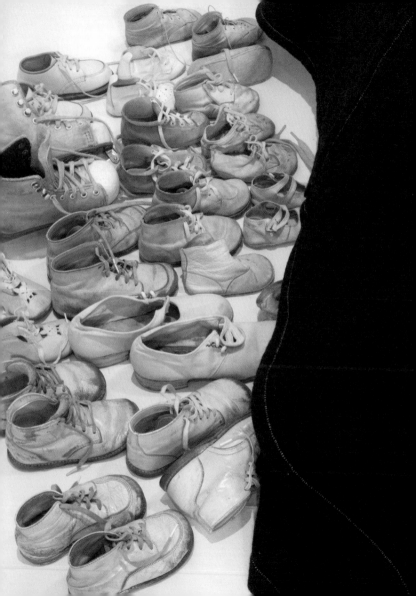

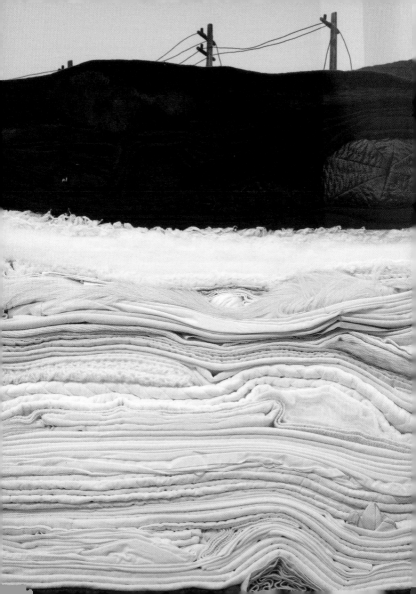

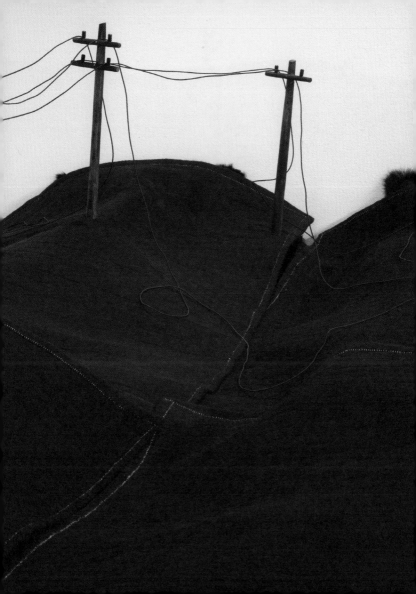

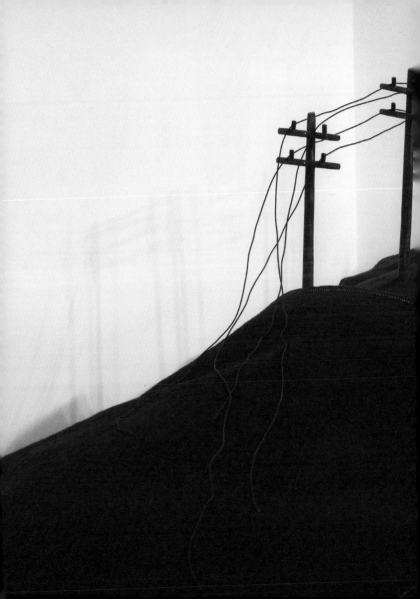

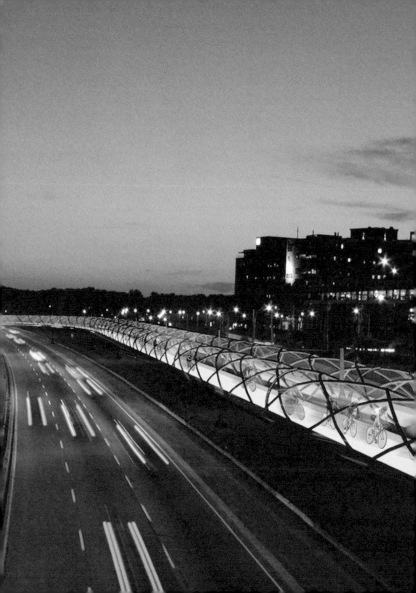

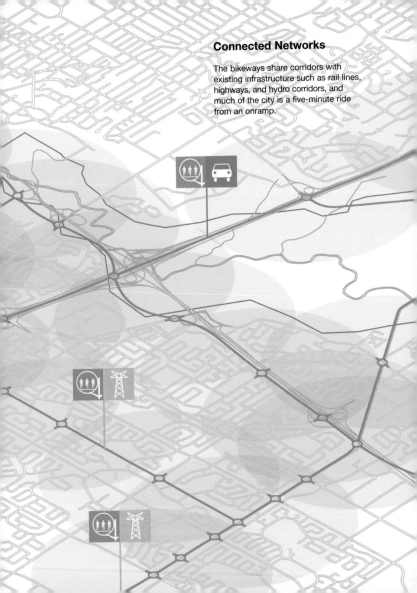

Connected Networks

The bikeways share corridors with existing infrastructure such as rail lines, highways, and hydro corridors, and much of the city is a five-minute ride from an onramp.

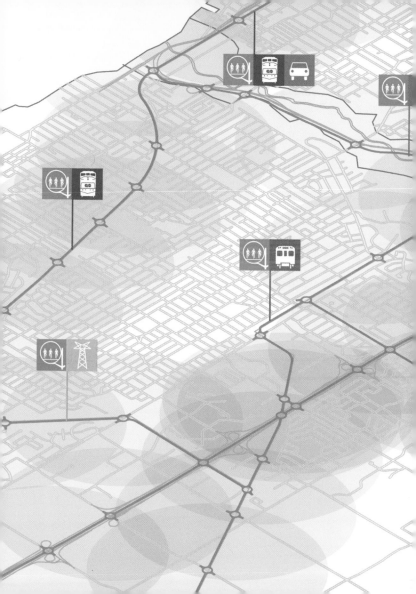

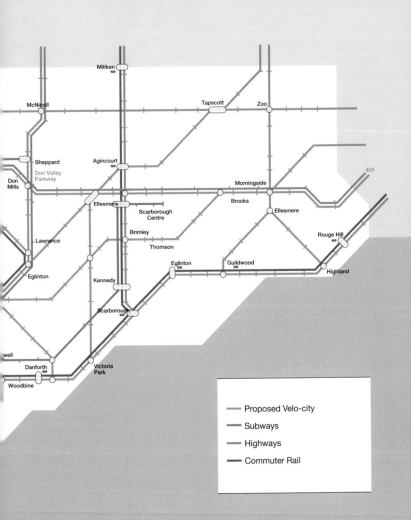

Proposed Velo-city
Subways
Highways
Commuter Rail

Proposed Velo-city in Toronto

A network of bikeways that share transportation corridors and connect with other modes of transportation.

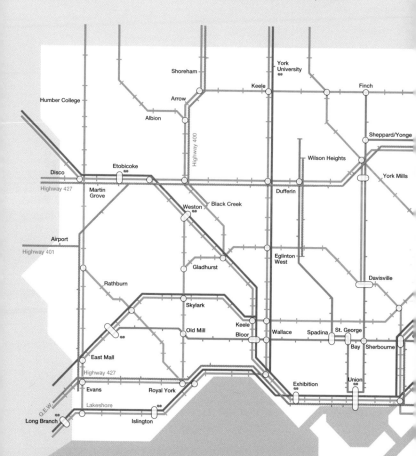

Velo-city is much smaller and lighter than
equivalent automobile highways.

Scale comparison

Velo-city is a significant piece of
transportation infrastructure that fits
within existing corridors.

It can float above existing routes.

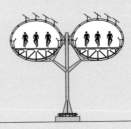

Double hung
horizontal tube with
top support
**Ideal for: crossings
and connecting
to existing structures**

Double hung
horizontal tube with
bottom support
**Ideal for: high volume
highway line**

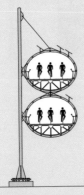

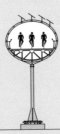

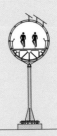

Double hung
vertical tube
**Ideal for: downtown
core, tight spaces
with high volume**

Standard tube
**Ideal for: most
spaces**

Narrow tube
**Ideal for:
On/off ramp tube**

How Velo-city fits into the city

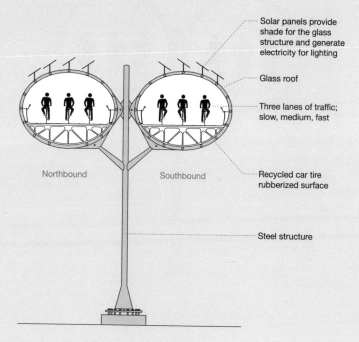

Solar panels provide shade for the glass structure and generate electricity for lighting

Glass roof

Three lanes of traffic; slow, medium, fast

Northbound

Southbound

Recycled car tire rubberized surface

Steel structure

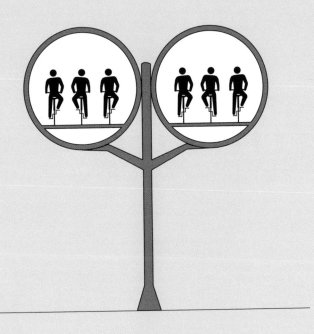

Velo-city is an active transportation infrastructure.
It is a protected space to travel in.

Transportation Choices

Velo-city offers an active way to get
around the city.

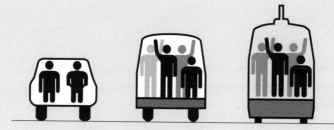

All modern forms of transit are passive.
People are carried like cargo in boxes on wheels.

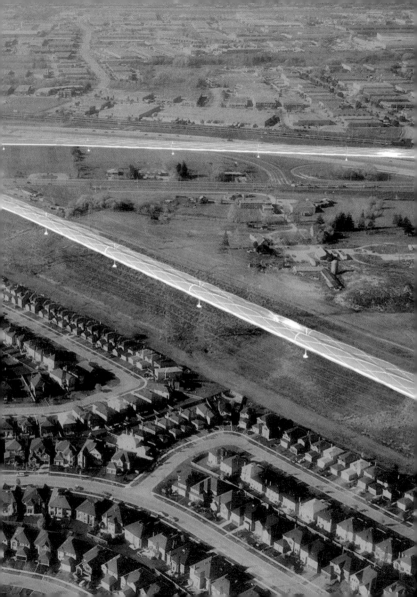

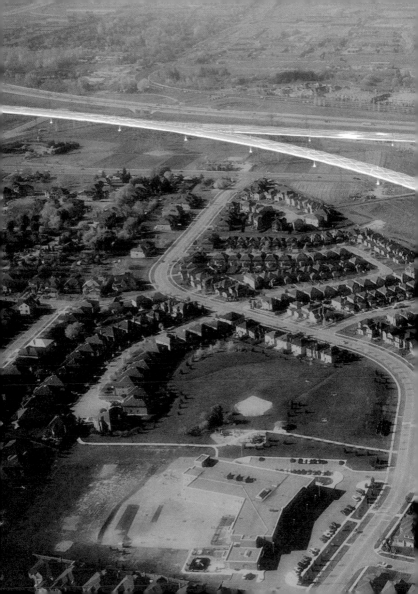

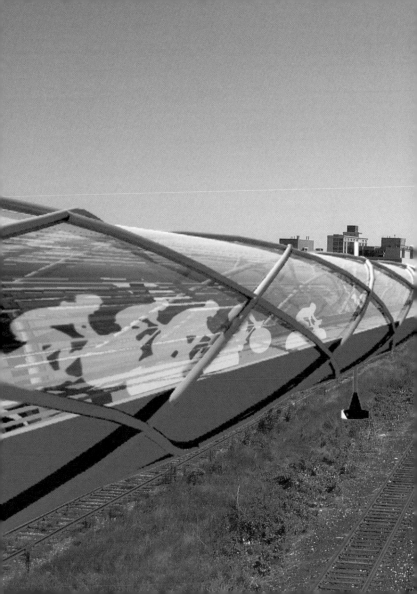

lower than the expense of keeping subways and highways in good operational order, because the weight and vibration of bicycles is considerably less than that of automobiles or railways. And because Velo-city is covered, the lane surfaces would be sheltered from weather distress.

The culture of a city is often defined by its transportation system: yellow cabs in New York City, bicycles in Beijing, streetcars in San Francisco, freeways in Los Angeles, double-decker buses in London, scooters in Taipei, *vaporetti* in Venice, cyclos in Ho Chi Minh City, and the Paris Metro. Modes of transport create interdependent relationships with urban forms and city culture. Think of the relationships between cars and shopping malls, subways and skyscrapers, streetcars and main streets, scooters and roadside stalls. Over time, Velo-city will create a cycling culture for the cities it inhabits: kiss 'n' rides, shower facilities, cycling fashion shops, velodomes, bike parks, health clubs, cycle path stalls, repair shops, bike couriers, bike picnics, car-free housing and intermodal stations. Velo-city would simply give bicycles the same level of dedicated infrastructure that other modes of transportation have enjoyed.

The bicycle has been around for more than a hundred years. It was a brilliant, modern invention back then, and remains one today. Bicycle enthusiasts have always been tenacious and devoted. And now, perhaps, it is an idea whose time has come back—bicycles now outsell automobiles in North America.

Velo-city is a highway for bikes, a network of elevated bicycle roadways connecting distant parts of the city. There are three lanes of traffic—slow, medium, and fast—in both directions, each direction having a separate glass-roofed bikeway tube. The separation of directions reduces wind resistance and creates a natural tailwind for cyclists. The reduction of air resistance increases the efficiency of cycling by about 90 percent, allowing for speeds of up to 50 km/h.

Because it is elevated, Velo-city can be located in existing highway, power, and railway corridors, adapting to the built environment while requiring no additional real estate. Bikeways float above intersections and fit into spaces where trains, subways, and roads simply can't go due to their size, noise, and pollution. Light and compact (you can fit seven bicycles in the road space taken up by one car) Velo-city produces no noise or pollution, so it can run right beside or even into buildings.

For commuters, Velo-city delivers total travel times that rival any other form of high-speed transit, and it is active rapid transit. In contrast to the passivity of taking a train or a bus, it includes exercise as an essential part of an urban lifestyle. Personal independence is expressed in individual freedom of movement. By working as a parallel infrastructure connected to subways, railways, highways, and parking lots, the bikeways expand commuting choices, while reducing congestion on our transit systems and highways.

Bikeways are the ultimate in efficient, health-generating rapid transit.

Maintenance costs for Velo-city would be substantially

the panorama of the city. Up ahead, you see a friend's familiar bike trailer—he's taking the kids to daycare. Pulling into the slow lane you chat for a few minutes before they get to their off-ramp.

Soon the bikeway opens up, widening to six lanes as you pass the commuter train station. Hundreds of suburbanites on yellow bikes merge smoothly into traffic. As you cross a valley, high above the expressway, the sun breaks through the clouds. You shift down, and take the next exit to work. Checking your watch, you notice you are early again.

Welcome to Velo-city.

It's Monday morning. You grab your gear and strap your bag onto your bike. It is cold and raining, and the traffic's heavy, but it's only a few minutes to the bikeway. Here it is. A quick lane change and you are pumping your way up the on-ramp and gliding through the entrance. The street noise falls away as you join the flow. Already you feel the draft of the other cyclists blurring past in the fast lane, their steady wind pulling you forward. You relax into the rhythm and the tension leaves your shoulders as you let down your defenses. No more cars breathing down your neck.

You ride along, matching your speed to those around you and looking through the raindrops on the glass-domed tube at

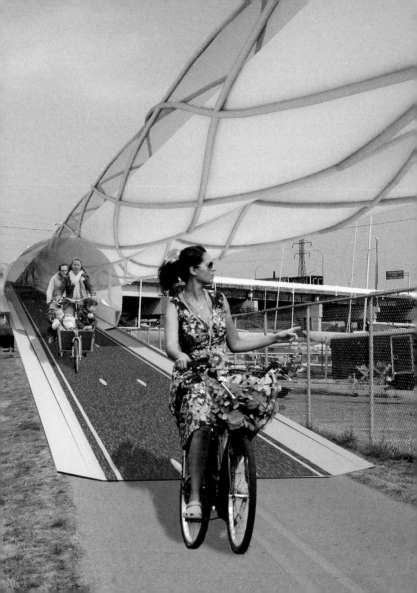

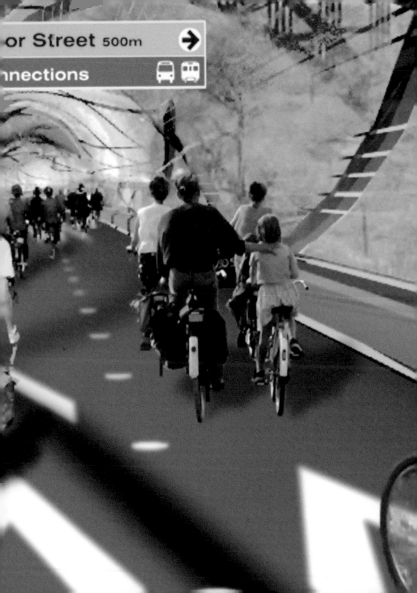

or Street 500m →

nnections

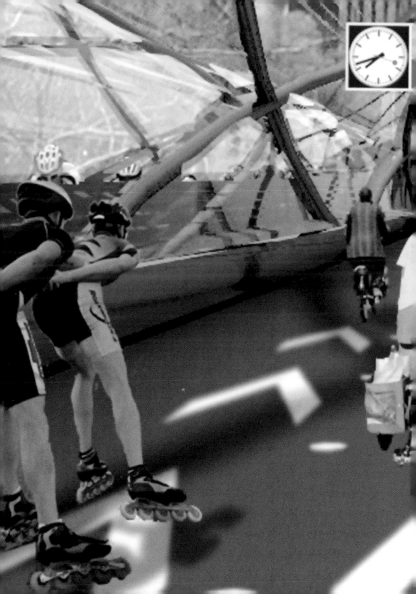

'CYCLE TRACKS WILL ABOUND IN UTOPIA'

– H.G. Wells, *A Modern Utopia*

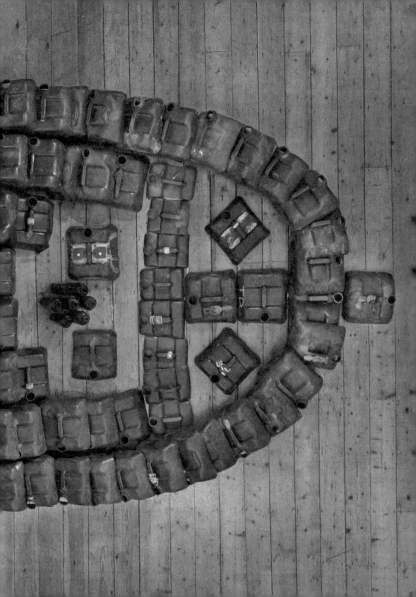

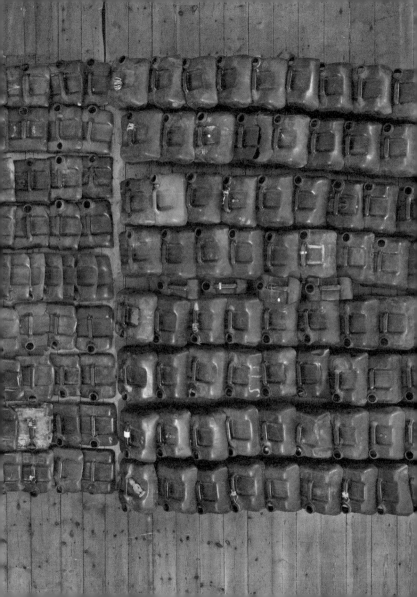

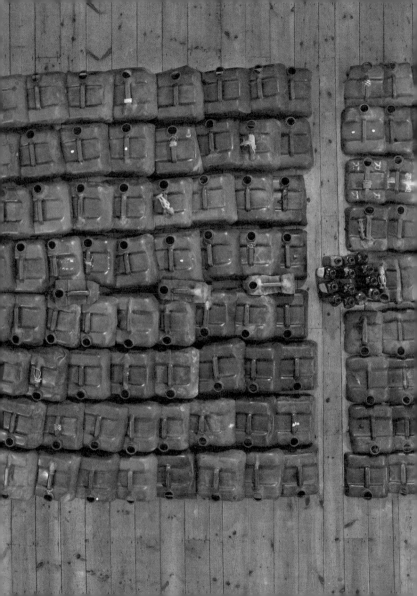

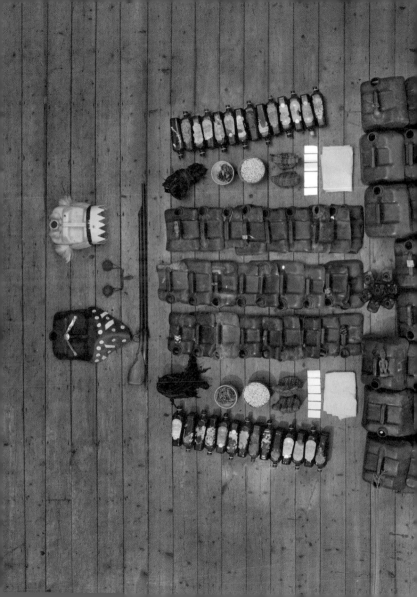

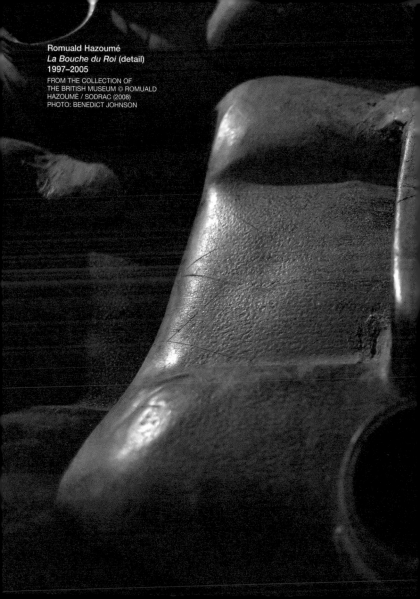

LA

ROMUALD HAZOUMÈ

BOUC

DU RO

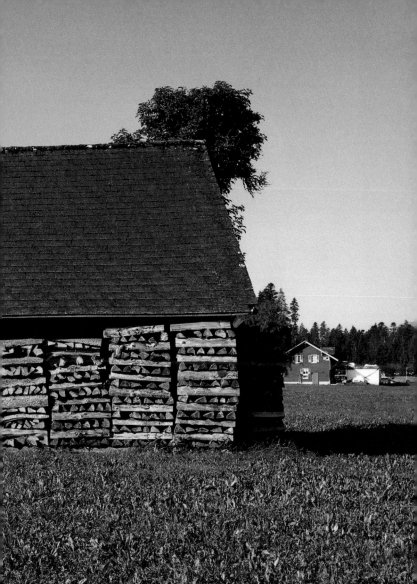

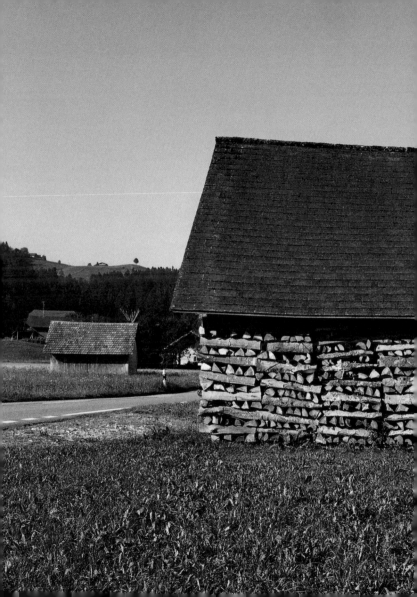

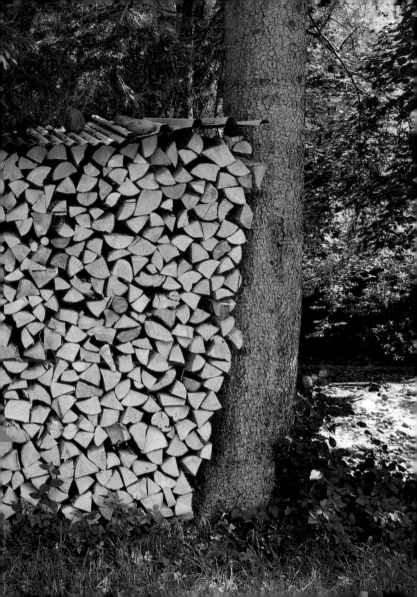

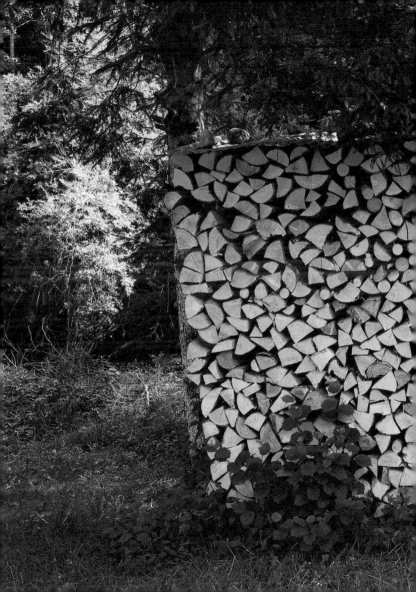

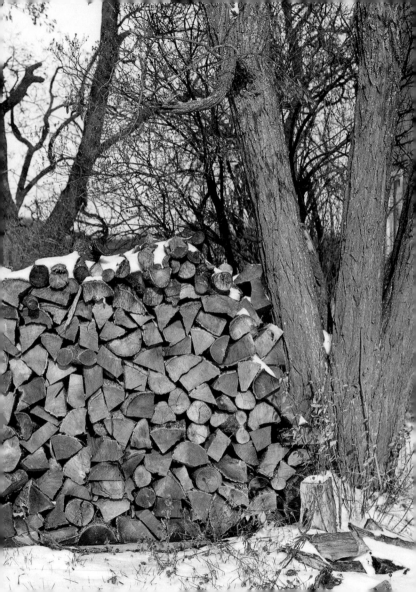

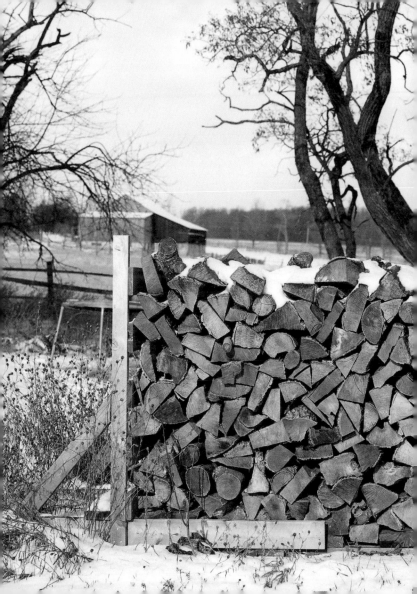

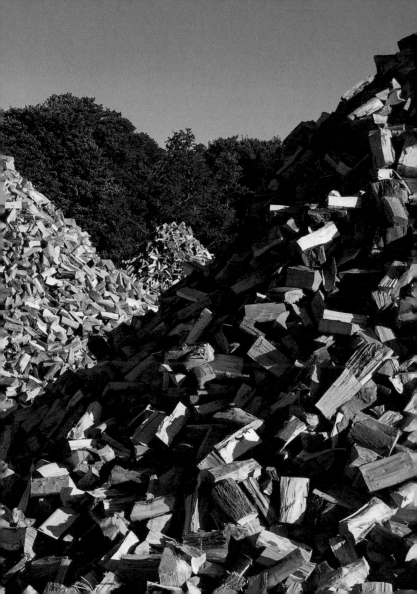

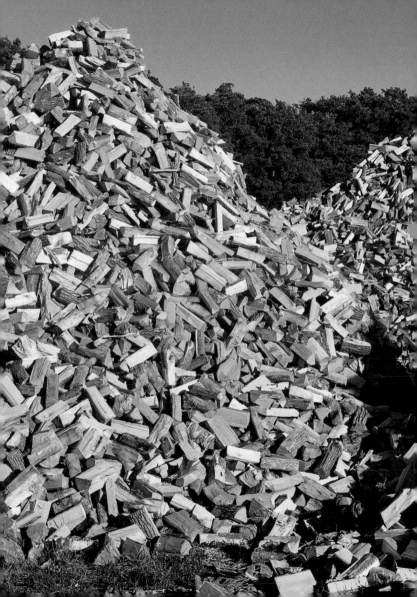

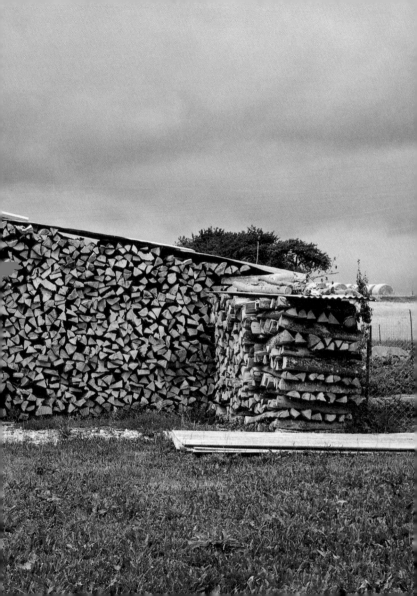

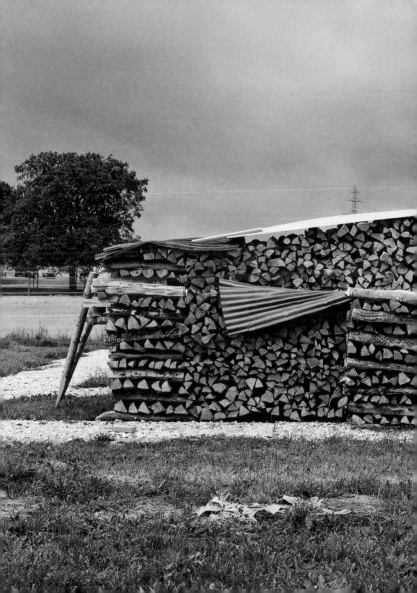

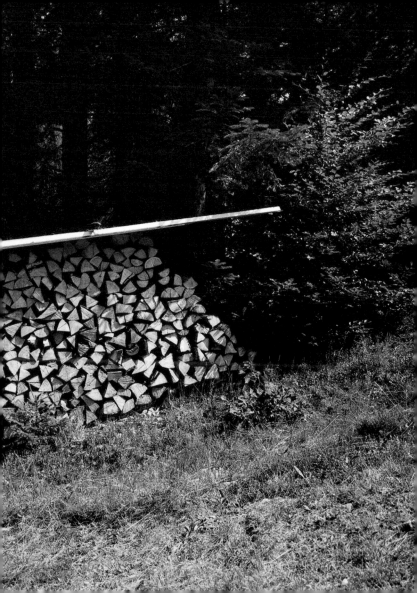

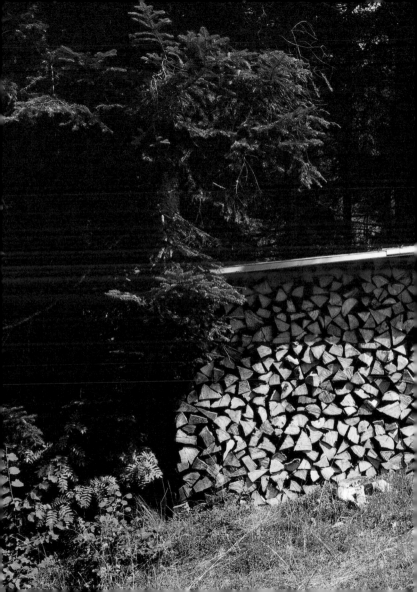

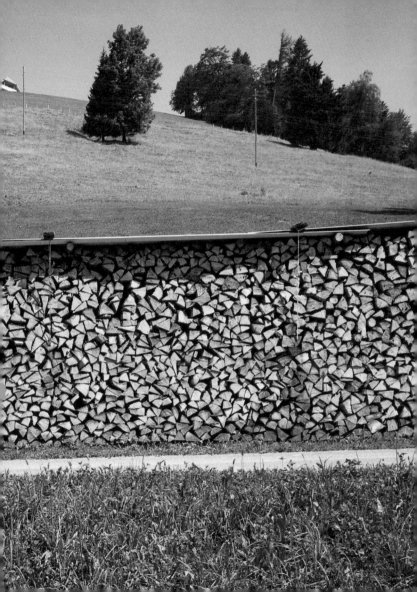

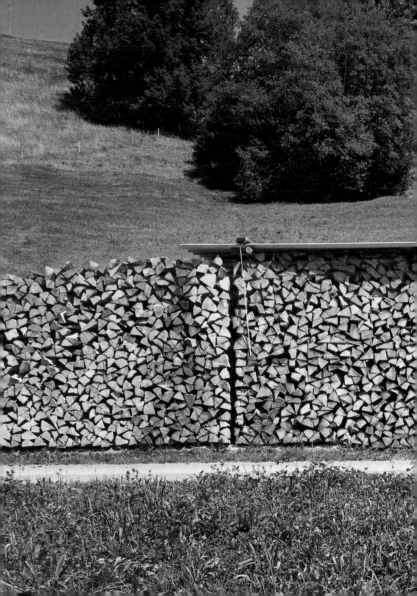

VID
INGELEVICS

DOODLES

Ontario Ministry of Infrastructure
Renewal (2006)
Places to Grow:
Growth Plan for the Greater
Golden Horseshoe
http://www.placestogrow.ca

Ontario Ministry of Transportation
(2004)
Goods Movement in Central Ontario:
Trends and Issues
Technical Report December

Ontario Borders — Southern Highways
Program Part II :
Looking Forward 2007–2011
www.mto.gov.on.ca

Traffic Volumes 1988–2004
www.mto.gov.on.ca

Regional Plan Association (2006)
America 2050: A Prospectus
New York: September
www.america2050.org

John Shragge
Highway 401: The Story
www.roadscholar.on.ca/lateststory.html

Statistics Canada
Canada's Population Estimates
www.statcan.ca

American Association of State Highway and Transportation Officials (2007)
A New Vision for the 21st Century
www.transportation.org

Sharon Bagnato and John Shragge, eds. (1994)
From Footpaths to Freeways: The Story of Ontario's Roads
MTO Historical Committee Public and Safety Information Branch

Pierre Belanger and Isobel Iarocci (2007)
Foodshed: The Globalized Infrastructure of the Ontario Food Terminal
In *FOOD*, John Knechtel, ed.
Cambridge and London: MIT Press

2008 Canada Focus (2008)
Ontario Drives Canada's Auto Industry
www.canadafocus.com/2001/sec04.htm

City of Toronto, Solid Waste Management:
Facts About Toronto's Trash
www.toronto.ca/garbage/facts.htm

Adam Clark (2007)
Spiking Ontario: Attention-Based Bandwidth Urbanism
Unpublished Paper, University of Waterloo
East-West Gateway Coordinating Council (2000)
Highway Runoff and Water Quality Impactswww.ewgateway.org

Keller Easterling (1999)
Organization Space
Cambridge and London: MIT Press

Keith S. Goldfeld, ed. (2007)
The Economic Geography of Megaregions
Trustees of Princeton University:
New Jersey
http://www.princeton.edu

Government of Ontario, Ministry of Transportation News
McGuinty Government Highway Investment Supports Auto Industry
http://ogov.newswire.ca/ontario

Government of Canada, Innovation in Canada
Provincial Analysis—Ontario
http://innovation.gc.ca
Brian Gray (2004)
GTA Economy Dinged by Every Crash on the 401—North America's Busiest Freeway
Toronto Sun, April 10

Industry Canada (July 2007)
Key Small Business Statisticswww.ic.gc.ca
Ontario Greenhouse Vegetable Growers
2008 January Fact Sheet
www.ontariogreenhouse.com/folders/show/807

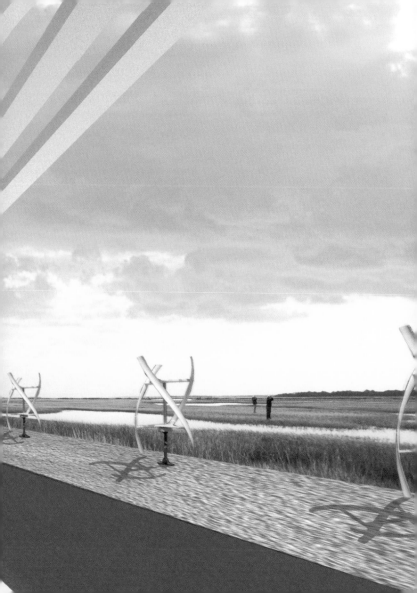

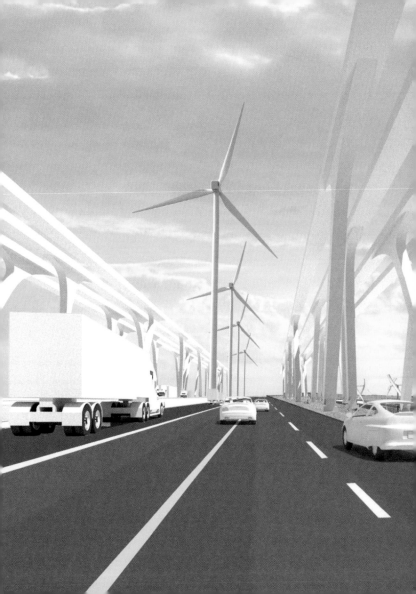

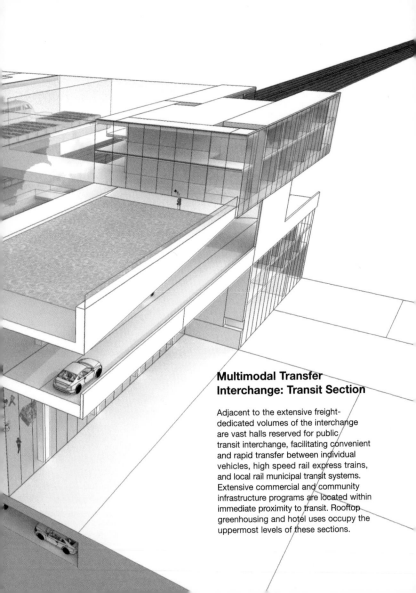

Multimodal Transfer
Interchange: Transit Section

Adjacent to the extensive freight-
dedicated volumes of the interchange
are vast halls reserved for public
transit interchange, facilitating convenient
and rapid transfer between individual
vehicles, high speed rail express trains,
and local rail municipal transit systems.
Extensive commercial and community
infrastructure programs are located within
immediate proximity to transit. Rooftop
greenhousing and hotel uses occupy the
uppermost levels of these sections.

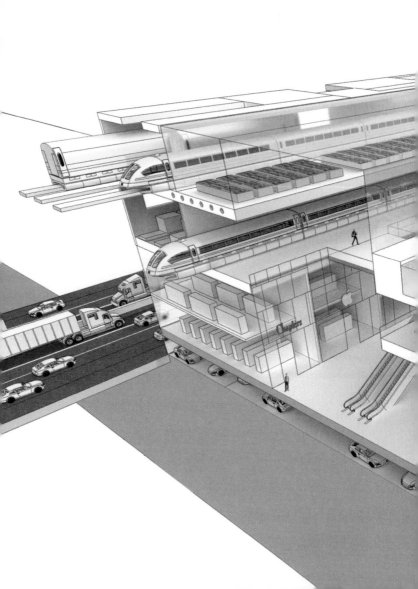

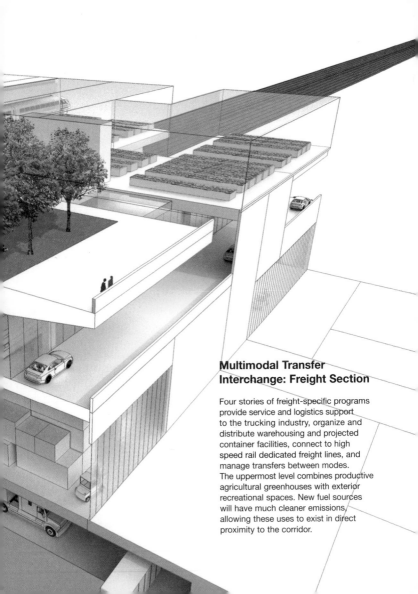

Multimodal Transfer
Interchange: Freight Section

Four stories of freight-specific programs
provide service and logistics support
to the trucking industry, organize and
distribute warehousing and projected
container facilities, connect to high
speed rail dedicated freight lines, and
manage transfers between modes.
The uppermost level combines productive
agricultural greenhouses with exterior
recreational spaces. New fuel sources
will have much cleaner emissions,
allowing these uses to exist in direct
proximity to the corridor.

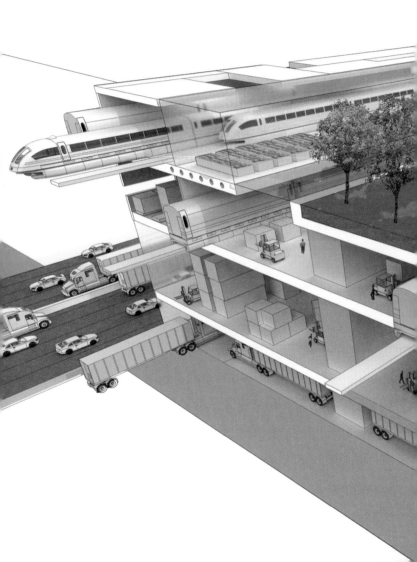

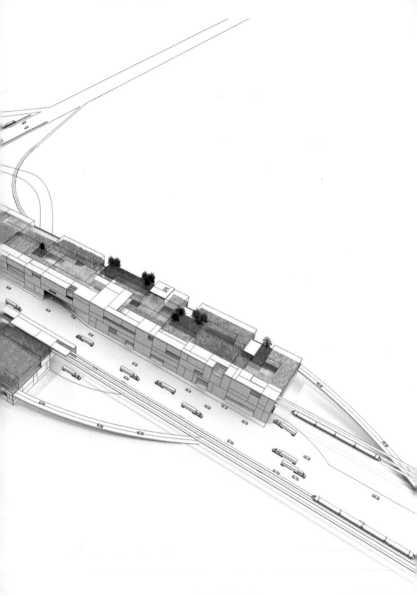

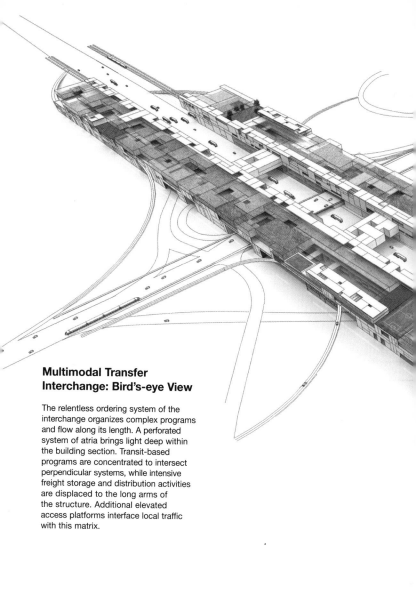

**Multimodal Transfer
Interchange: Bird's-eye View**

The relentless ordering system of the
interchange organizes complex programs
and flow along its length. A perforated
system of atria brings light deep within
the building section. Transit-based
programs are concentrated to intersect
perpendicular systems, while intensive
freight storage and distribution activities
are displaced to the long arms of
the structure. Additional elevated
access platforms interface local traffic
with this matrix.

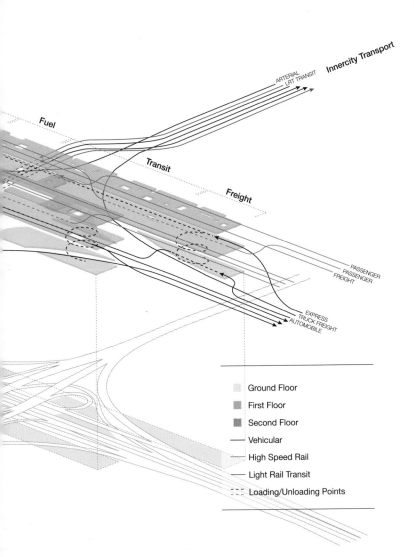

Innercity Transport

Fuel

ARTERIAL
LRT TRANSIT

Transit

Freight

PASSENGER
PASSENGER
FREIGHT

EXPRESS
TRUCK FREIGHT
AUTOMOBILE

Ground Floor

First Floor

Second Floor

Vehicular

High Speed Rail

Light Rail Transit

Loading/Unloading Points

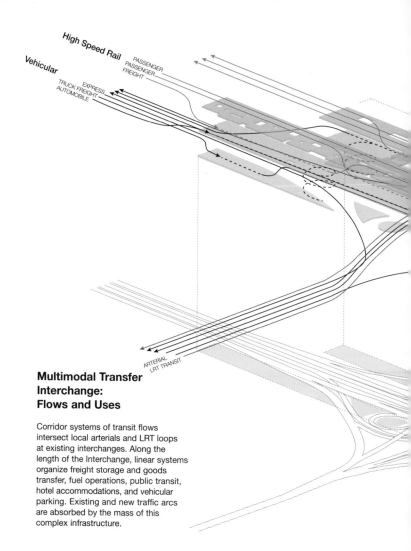

High Speed Rail

Vehicular

PASSENGER
PASSENGER
FREIGHT

EXPRESS
TRUCK FREIGHT
AUTOMOBILE

ARTERIAL
LRT TRANSIT

Multimodal Transfer Interchange: Flows and Uses

Corridor systems of transit flows intersect local arterials and LRT loops at existing interchanges. Along the length of the Interchange, linear systems organize freight storage and goods transfer, fuel operations, public transit, hotel accommodations, and vehicular parking. Existing and new traffic arcs are absorbed by the mass of this complex infrastructure.

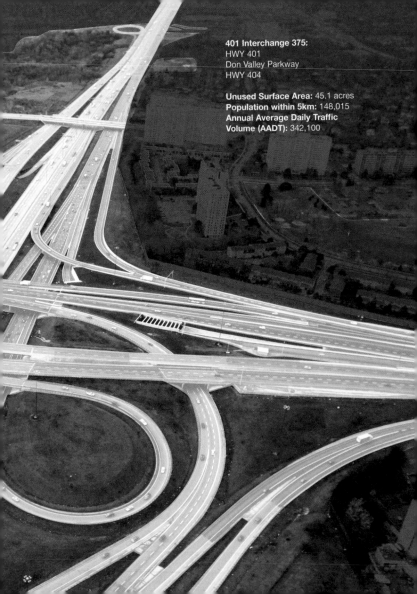

401 Interchange 375:
HWY 401
Don Valley Parkway
HWY 404

Unused Surface Area: 45.1 acres
Population within 5km: 148,015
**Annual Average Daily Traffic
Volume (AADT):** 342,100

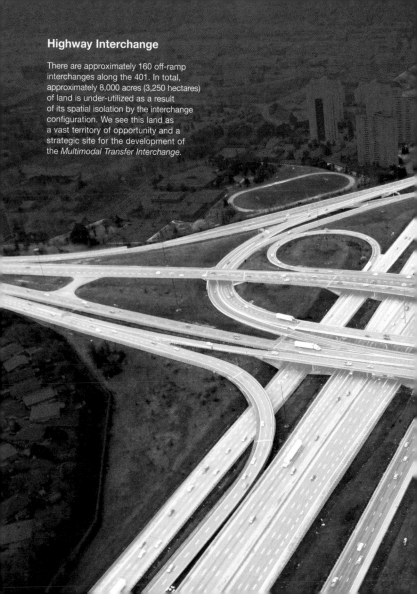

Highway Interchange

There are approximately 160 off-ramp
interchanges along the 401. In total,
approximately 8,000 acres (3,250 hectares)
of land is under-utilized as a result
of its spatial isolation by the interchange
configuration. We see this land as
a vast territory of opportunity and a
strategic site for the development of
the *Multimodal Transfer Interchange*.

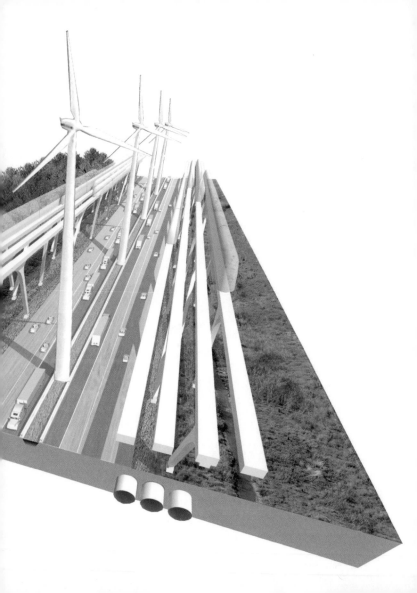

The Post-Carbon Highway...

...will not only have new lines for high speed rail and dedicated freight, but will also generate its own energy from wind turbines along its median, photovoltaic panels above the rail lines, and vertical axis turbines that convert energy created from wheels along the road surface. New infrastructure to support urban growth, such as water, sewer, cable, and power lines, will be carried along the highway. Road chemicals and NaCl runoff will be mitigated by particle separator catch basins within the central median and drought- and salt-tolerant plantings on either side of the highway.

line and as an urban and ecological enabler will yield rich opportunities for new occupations and modes of living in the post-carbon era.

interchange renders unusable an average of 44.3 acres (18 hectares) of surface immediately adjacent to these flows. What if we placed intensively programmed nodal hubs directly on existing exits? These new structures would cohabit with the space of the highway and mediate the increased bandwidth of the system, while forming impressive interior public spaces whose mix of program and transportation confluence could rival the grand railway stations of the nineteenth century and the major airport terminals of the twentieth.

The traditional highway service center with its minimal amenities—fuel station, fast food joint, strip motel—is no longer sufficient. In the post-carbon era of new fuels, a variety of refueling systems will be needed at every service point, each fully integrated with the differentiated modes of travel. Freight transfer points complete with sorting and distribution capacity will facilitate the transfer of goods along the highway's length. Parking facilities, easily accessible to the transit interchange, will encourage people to leave their cars and choose to take advantage of a faster and far more energy-efficient mode of travel. The transfer interchange will also become a vibrant site for new services, shops, and entertainment for the people living in the multicentered urban region. Fresh food terminals for local organic farmers, daycares, shopping centers, postal and courier stations would connect residents and businesses with the space of the highway.

In a post-carbon era, it is clear that we need to reimagine the potentials of our existing infrastructure systems. Adapting and retooling the 401 into an intensified, complex economic trunk

Freight
MJ/tonne-km

Freight Train	160 km/h, 60 tonnes/car 401 Trip Time: 5hr 7 min	
	0.22	
High Speed Freight Train	430 km/h, 40 tonnes/train set 401 Trip Time: 1hr 54 min	
	0.58	
Tractor Trailer	100 km/h, 10–60 tonnes 401 Trip Time: 8 hr 12 min	
	1.18	
Freight Truck	100 km/h, 10–60 tonnes 401 Trip Time: 8 hr 12 min	
	2.41	

Transport Modes and Performance

The fuel performance, velocity capabilities, and economic contribution of existing transportation types are compared to HSR alternatives. Within megaregions, HSR is anticipated to emerge as the highest-performing transport type for trips under 800km.

Passenger
MJ/passenger-km

High Speed Passenger Train	430 km/h, 100 passengers/train set 401 Trip Time: 1hr 54 min	0.25
Commuter Train	133 km/h, 160 passengers/car 401 Trip Time: 6 hr 9 min	1.79
Car	100 km/h, 1–5 passengers 401 Trip Time: 8hrs 12 min	2.36
Airplane	913 km/h, 524 passengers 401 Trip Time: 53 min	2.44
SUV	100 km/h, 1–5 passengers 401 Trip Time: 8hrs 12 min	3.27

401 and Yonge St.

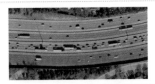

RESIDENTIAL

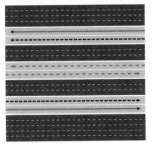

RESIDENTIAL

401 and 416

FARMLAND / FOREST

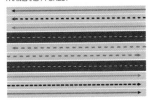

FARMLAND / FOREST

Vehicular system isolates local traffic to the outboard edge of corridor, concentrating express traffic in central lanes. HSR freight lines displaced to corridor center to facilitate high-volume transit interchange at key urban sites.

Beyond the GTA, a reduced road capacity is complemented by long range HSR routes above, organized to permit local freight distribution along the corridor.

401 and 403

401 and 427

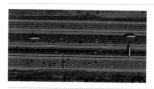

INDUSTRIAL

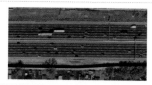

INDUSTRIAL

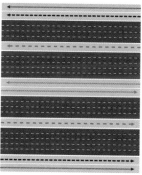

INDUSTRIAL

RESIDENTIAL

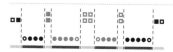

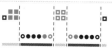

Intensive separation of local and express routes and highly differentiated HSR line system, complete with multi-level track conduits.

Vehicular separation organizes an increase of local freight capacity adjacent to industrial uses and coordinates the position of HSR freight capacity within proximity of urban edge conditions.

401 / Windsor

INDUSTRIAL / FARMLAND

INDUSTRIAL / FARMLAND

401 / Waterloo

INDUSTRIAL / FARMLAND

INDUSTRIAL / FARMLAND

Highway capacity increased with dedicated transit and freight lines differentiated by trip distance. Elevated high speed rail added to the outboard extent of the corridor.

Increased road and rail capacity augmented by dedicated HSR lines for express commuter transit displaced to the central lane of the corridor.

Retooling for the
Post-Carbon Highway

Analysis of a variety of typical sections
along the 401 illustrates how the
current line can be modified to add
elevated high-speed passenger and
freight rail (HSR), high-occupancy vehicle
lanes (HOV), and dedicated truck lanes.
In undeveloped sections, the new
lanes and rail lines can spread to either
side of the highway. In urban conditions,
the new infrastructure lines will need
to be vertically stacked. Modifications
to the system apply the concepts of
multiplexing and densification along its
length, but respond to local variations.

Highway

Current View
of Highways

Proposed Retooling of Highways
Plan View

Section View

Benefits of Retooling

LOCAL EXPRESS

——— ——— Passenger HSR
- - - - - - Freight HSR

● ● Passenger Car
○ ○ Freight Truck
□ □ Freight HSR
■ ■ Passenger HSR

Proposed Retooling
Additions

Existing Highway
Surface

□■▮ Aboveground Rail

●○ Surface Transport

addition of a self-generated power supply. It could carry main water lines to support growth on its edges. Indeed, the 401 could be configured as a form of mega–trunk line whose primacy within the region is the equivalent of a geologically scaled feature central to the organization of all physical and logistical distribution. The transformational potential of such a radical reimagining of its components is enormous. Beyond its performative capacity as an enabler of distribution, the generous buffer zones of open land on either side of the highway could be strategically planted with species such as staghorn sumac, snowberry, and red-osier dogwood, and combined with chemical separator infrastructure for processing salts and other hazardous vehicle-based oils and particulates, could serve as an immense landscape project with all the traditional scenic benefits to the driver while generating complementary economies and ecologies.

Multimodal Transfer Interchange

As the 401 intensifies, a new typology, *the multimodal transfer interchange*, will become the key node along the highway and a dominant post-carbon urban construct. These interchanges will be places where the highway and its travelers will be able to interface with its dependent population concentrations. The strategic sites and available footprint for such interchanges are already determined by the logic of the existing system. At the moment, each of the 160 off-ramp interchanges along the 401 simply facilitates changes of speed and direction. Exquisitely engineered choreographic arcs allow individual drivers to negotiate these movements smoothly, but the architecture of each

including high speed rail and dedicated vehicle lanes will be configured in a "thick" system where transport types are stacked and separated to maximize speed, safety, and accessibility.

The maximum speed posted on the 401 is 100km/h, but the highway was designed to operate at a much greater velocities, at least 130km/h, and it curves only gently, if at all, for most of its length. The vehicles operated by most drivers are also designed for higher speeds, and the boredom of not being allowed to go faster has been a common complaint among regular 401 travelers. This very aspect of the 401's design means that it could easily be adapted to include dedicated high-speed travel corridors, providing efficient and rapid long-distance transit.

If the population of the region grows at the expected rate (and the data indicate that this increase is already underway), public transit systems linking this continuous urban corridor will certainly be a viable option, especially if intermodal interchanges, where passengers can easily and efficiently transfer from private vehicles to mass transit, are integrated within the system at key sites. Given the volume of regular freight and just-in-time delivery that currently passes between locations along the 401, a high speed rail (HSR) freight system capable of moving standardized containers should be incorporated. A version of this system is already under development by Siemens utilizing maglev technologies, and includes container and trailer based options.

The post-carbon highway's innovations will begin with increasing speed, efficient mobility, and interchange with other transport systems, but the changes will not end there. The space of the highway could become further multiplexed with the

Configuration
Alters Capacity

This chart shows a range of wire rope cross-sections, each with a unique configuration of essentially the same components, resulting in different physical characteristics for each combination. We propose that a similar concept holds true with respect to transportation infrastructure. By increasing the quantity and configuration of access conduits the highway can increase its bandwidth, and perform in new ways.

inclement weather slow this transfer rate to unacceptable levels, entire regional economies suffer. In 1998, internet access providers began switching from telephone lines to cable in order to gain increased bandwidth, and thus speed. Most short-distance-communication optical cables comprise what are known as multimode, or multiplex, fibers. These allow multiple wavelengths of light to be transmitted along the same cable bundle. Cable companies call this "increasing power." What it actually means is that multiple transmissions of light can travel at different speeds, within the same space.

A similar concept can be applied to the post-carbon highway. Instead of having the surface of the highway being universally accessible to all vehicle types traveling at various speeds, the power of the highway would be increased if it were differentiated to accommodate different vehicle types and speeds, in effect becoming a network of parallel, cooperative modes of mobility. A simple version of this scenario exists in almost every North American metropolitan center where faster through traffic (express) is separated from traffic entering or exiting from the urban road system (collector). This differentiation could be further exploited, also separating vehicles by type, size, fuel, destination, and maximum speed. The notion that one surface can serve all is ultimately a naive result of the early days of motorization when private motor vehicles were the primary users of the highway, and transit and shipping used primarily rail or water. Now that the open road is terminally congested, what is needed is a new, intelligent approach to horizontal mobility. In order to optimize the highway's bandwidth, a variety of transportation types

of time in transit. Suburban developments are as popular and profitable as ever even as sprawl continues to displace them further and further from employment centers. At the same time, economies are also becoming more and more dependent on mobility as the cost of moving goods continues to decline even as the cost of fuel is increasing. In fact, truck-borne freight is expected to double by 2035 (American Association of State Highway and Transportation Officials, 2007 report, 57). Given these trends, it appears that the road system will not be abandoned and instead will need to be retooled to accommodate new modes of access, interface, and energy delivery to meet increasing demand.

The future of energy is emerging as a transformation from single-sourced fuel to a blended matrix of inputs from a variety of sources, including solar, wind, nuclear, carbon, geothermal, biofuel, and others. The collapse of the fossil fuel system does not mean that the highways will be empty. Rather, the system will have to be reevaluated and genetically redesigned to do more. Simply adding lanes to the existing system cannot avert the crisis facing superhighways like the 401. The post-carbon highway will need to become much more intelligent in how it organizes goods, people, and energy along its length.

Increasing Bandwidth

"Bandwidth" has become a household word; anyone who uses a computer to access the internet is familiar with the term, which refers to the data transfer rate measured in bits per second. When engineers consider the capacity of a highway, they measure the transfer rate of vehicles per hour. When traffic, accidents, or

the motor vehicle. Thus, the favored mode of transport becomes the only one possible.

The singular type of access and interface that was built into the original design is the basis for its success, and the "dumb" simplicity of the system has made it the dominant model in North America and around the world. The highway system, combined with the automobile industry, has surpassed all other transportation typologies in the last century.

Retooling

Every initially simple system, if it is successful, reaches a critical level of complexity at which it begins to fail. Beyond that point, it will need to be retooled and redesigned in order to continue to operate. For the 401, this moment of complexity is imminent. The simplicity that worked so well in the beginning has led to a condition of practical absurdity nearing system collapse. This crisis happens to coincide with the moment when the gasoline-powered motor vehicle also appears to be close to the end of its usefulness, as the plentiful and cheaply accessible carbon-based fuels we have depended on grow scarce. The world is entering a post-carbon energy era.

It was once thought that the depletion of carbon-based fuels would precipitate a decline in mobility coupled with the corresponding demise of the automotive industry, but trends point in the opposite direction. Against all good advice, people continue to rely on their cars, shifting jobs and residences with increasing frequency on the assumption that they can always drive wherever they need to go, and spending increasing amounts

System Load

Over 71,000 tonnes of salt (NaCl) is dumped on the 401 annually in deicing operations. Fuels and pollutants containing nitrogen, phosphorus, lead, zinc, iron, copper, cadmium, chromium, nickel, and C_5H_{12} contaminate surface water and soils along its length (East-West Gateway Coordinating Council, Table 2). The 401's original planning located the route in direct proximity both to acres of the most valuable agricultural land in the country and to the drinking water supply of the watershed. The province currently exempts road salt from its environmental protection laws even though it is toxic to plants and animals; a comprehensive study to evaluate the net economic and ecological effect of escalating salt concentrations in ecological systems immediately adjacent to the 401 system has yet to be undertaken. What is clear, however, is that an ever-increasing number of vehicles currently demand the maximum velocity available from the 401, and during five months of the year continuous deicing is essential to road safety.

Dumb System

Architect Keller Easterling has pointed out that, instead of being designed as differentiated, adaptable, and interchangeable, the interstate highways were designed as "dumb networks with dumb switches" (Easterling 77). Like all North American highways, the 401 is a dumb system. It has only one purpose: to allow vehicles to move horizontally on a hard surface. All cars, trucks, and buses, regardless of their size, destination, freight type, or maximum speed, share the space of the highway equally. The asphalt surface systems that connect with the highway give access exclusively to

million people, in the next twenty-five years, primarily through immigration. The provincial government's 2005 plan for growth proposes to concentrate densification in certain urban and exurban centers, the majority of which are located along the Highway 401 corridor, which the report identifies as the major economic driver for the region (Ontario Ministry of Infrastructure Renewal, Places to Grow, 12).

Unsurprisingly, this pattern reflects the developmental trends of the megaregion. The official vision declares that access to mobility and physical connectedness will define a prosperous future, and the logic of densification appears to support that view: capitalizing on existing transportation networks sounds like a good idea, because the cost of maintaining remote physical infrastructures is high. But there is a risk involved in pairing rapid growth and an already congested system within a limited geographical space. The implications may be catastrophic: analysts are predicting that the system could degenerate into complete gridlock in a matter of years. The latest reports indicate that over 15,000 collisions occur on the 401 annually (Gray). Traffic congestion and delays on the 401 are already so severe that they are estimated to cost over $5 billion in lost GDP every year (Places to Grow, 7). In order for the region to remain competitive, new strategies are required to mediate these symptoms of dysfunction.

lanes (Bagnato and Shragge 93). Yet, even with such an immense girth, the 401 is currently operating at capacity.

This overloaded artery is a fundamental piece of economic infrastructure. In 2006, an estimated 4.6 million trucks traveled the Detroit-Toronto corridor (Shragge). The 401 is an essential conduit for the automotive industry concentrated in southern Ontario and Detroit; parts are shipped from the US for assembly in Canadian plants and then shipped back across the border in a coordinated just-in-time production system that is a mainstay for the economy of the megaregion and both nations. In 2006 947,000 tons of agricultural products were shipped to the Ontario Food Terminal in Toronto (Belanger and Iarocci 238), which acts as a distribution hub for the entire region, and Toronto shipped approximately 450,000 tons of garbage back into Michigan for landfill (City of Toronto). The 18 million acres of farms in the region use the 401 to distribute Canadian produce globally, and access to the corridor has created North America's most intensive concentration of greenhouse farming, mediating climate limitations on food production and facilitating rapid distribution of locally grown produce during winter months; 70 percent of the greenhouse produce is shipped to the US (Ontario Vegetable Growers). The 401 carries 448,000 tons of aggregate (MTO 2004, 197) and hundreds of thousands of commuters daily. The highway is an essential infrastructural system, whose operation is critical to almost every aspect of the region's economy.

Distress

Southern Ontario's population will grow by 30 percent, or four

Cambridge / Kitchener / Waterloo
Population: 422,514
Area: 312 km², 17.4 km, 4 interchanges

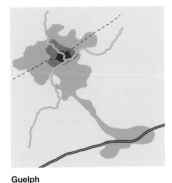

Guelph
Population: 127,009
Area: 378.45 km², 10 km, 2 interchanges

Windsor
Population: 108,000
Area: 2458 km², 21.8 km, 4 interchanges

Mississauga
Population: 668,549
Area: 288.42 km², 21.2 km, 5 interchanges

Urban Morphology of Cities along the 401

The cities of southern Ontario were found-
ed along water and rail routes. Highway
401 does not follow these original routes.
The darkest gray represents the historical
urban core, the next shade shows the
size of the city in 1950, around the time
Highway 401 was being completed,
and the lightest shade marks the current
extent of the city's footprint.

 Current City Extent

 1954 City Extent

 Historic Center

- - - Major Rail Corridors

Highway 401

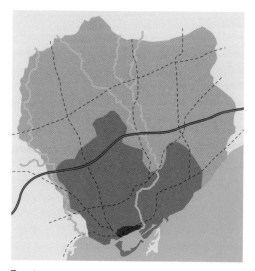

Toronto
Population: 5,555,912
Area: 7125 km², 34.3 km, 16 interchanges

it connected at the time, especially in southwestern Ontario. In fact, the portion that passes through the city of Toronto, known as the "Toronto bypass," was criticized at the time for being located too far away from the city's core to allow for convenient access and use (Bagnato and Shragge 93).

It quickly became apparent that the new highway would stimulate urban growth in adjacent communities. An entirely new settlement pattern began to emerge as, section by section, the highway was completed, and proximity became instantly popular, with development responding to this demand. The cities of southern Ontario were all originally located on water and rail access routes, the key determinants of eighteenth- and nineteenth-century settlement and trade patterns. Growth patterns after the construction of the 401 show a definitive movement towards the highway, with the larger municipalities building business parks and residential subdivisions on both sides of the highway's route, expanding to absorb this line into the municipal footprint.

Critical Capacity

The 401's desire-line route through a convenient path of least resistance has become a victim of its own success. Three years after the Toronto Bypass had been completed in 1956, it was carrying almost double the volume of traffic for which it had been designed, necessitating an ongoing series of expansion projects. Fortunately, due to its original distance from the city, a 300 meter right of way across the north of Toronto was relatively inexpensive to acquire and has proved invaluable as the 401 expanded multiple times to its current maximum width of eighteen

worth of goods to global markets (Government of Ontario, MTO News). Furthermore, it supports the majority of commuter traffic to and from several urban centers, including Toronto and its outlying municipalities.

Pattern Reorganization

The history of North American highway construction is a story of immense political and economic will marked by intense battles between competing visions as well as by fierce fights and tradeoffs over routes, proximity to cities, disruption of neighborhoods, and public expenditures in support of private enterprise. On the one hand, the highway has been positioned as a force for economic and social progress, while on the other it has been cast as a villain bringing environmental damage and the destruction of historic communities.

There are no such tales of friction in the case of the 401. Indeed, the process by which the route of the 401 was established may even be cited as an illustration of an unusually inclusive and democratic planning practice. Planning was underway in 1939 when the outbreak of World War II brought the process to a temporary halt. The Ontario Department of Highways (now the Ministry of Transportation or MTO) took advantage of the construction delay to undertake a survey asking 350,000 Ontario motorists what they would consider the most desirable line of travel from Windsor to Quebec, if such a road were to be built (Shragge). The resulting "desire line" thus established as the route of the 401 followed no existing road or rail line, and its entire length passed well out of the way of many of the settlements that

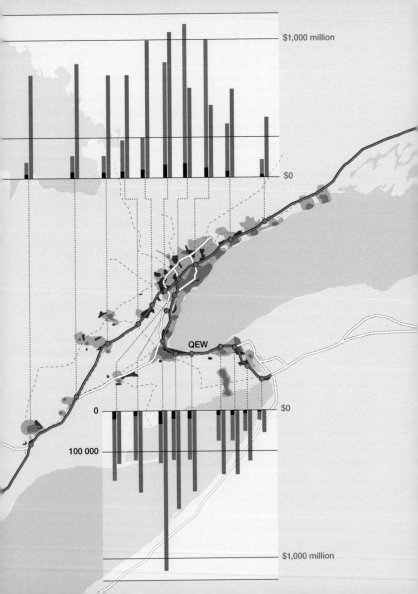

$1,000 million

$0

QEW

0

100 000

$0

$1,000 million

Highway 401
Modal Statistics

The 820 kilometers of Highway 401 carry
over $1.2 trillion worth of goods annually.
This value, compared statistically to the
volume of commercial and commuter
traffic within the 401 and QEW corridors,
provides an accurate indication of the
intensive stress placed on the system by
existing urban concentrations.

100,000

0

▮ Daily Freight Value ($millions)

▮ Annual Average Daily Traffic

▮ Annual Average Daily Traffic
 (Commercial Vehicles)

⬤ Current Urban Area

⬤ Pre-highway Urban Area

⬤ Primary Industrial Land

- - - Major Rail Corridors

═══ Highways

402

401

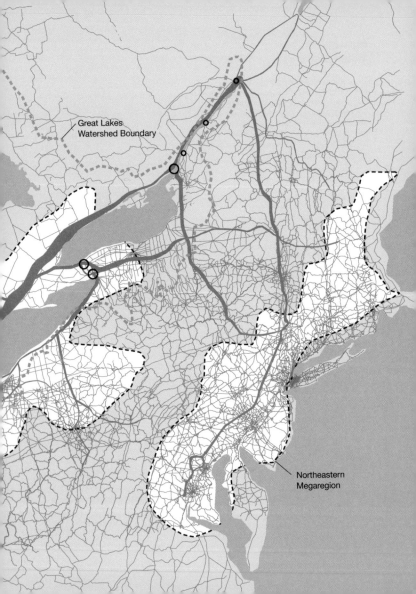

Great Lakes
Watershed Boundary

Northeastern
Megaregion

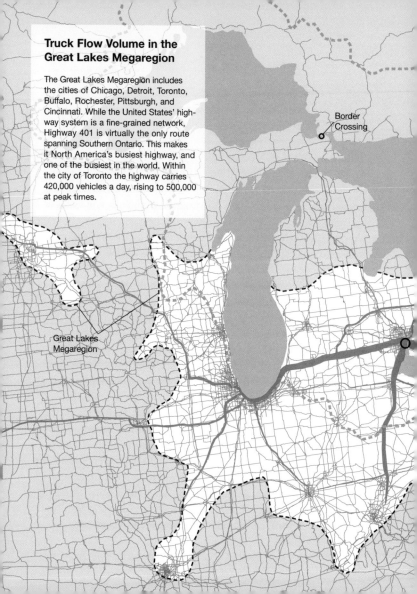

Truck Flow Volume in the Great Lakes Megaregion

The Great Lakes Megaregion includes the cities of Chicago, Detroit, Toronto, Buffalo, Rochester, Pittsburgh, and Cincinnati. While the United States' highway system is a fine-grained network, Highway 401 is virtually the only route spanning Southern Ontario. This makes it North America's busiest highway, and one of the busiest in the world. Within the city of Toronto the highway carries 420,000 vehicles a day, rising to 500,000 at peak times.

Border Crossing

Great Lakes Megaregion

scale, complexity, redundancy, and multiplicity will be the most urgent considerations for planners working to organize and integrate these new urban regions.

Situation: 401

The Regional Plan Association (RPA), which has been studying the development of megaregions throughout North America, has defined the Great Lakes Megaregion to include the cities of Chicago, Detroit, Toronto, Buffalo, Rochester, Pittsburgh, and Cincinnati. Within this region, Highway 401 is a freeway that runs for approximately 820 kilometers across Southern Ontario from the US border at Detroit through Toronto and into Quebec. It is North America's busiest highway, and one of the busiest in the world. The section of the 401 that cuts across the northern part of Toronto has been expanded to eighteen lanes, and typically carries 420,000 vehicles a day, rising to 500,000 at peak times, as compared to 380,000 on the I-405 in Los Angeles or 350,000 on the I-75 in Atlanta (Gray). While the United States' interstate system is a widely distributed network, with multiple routes between primary centers, the 401 is virtually the only line of movement spanning southern Ontario, where 39 percent of the Canadian population and 37 percent of Canadian business is concentrated (Statistics Canada). The 401 splits into tributary highways (the 403 and the QEW) only as it approaches the US border at Detroit and Buffalo. It carries 60 percent of all vehicular trade between Canada and the US. Daily, $900 million worth of goods crosses the Ontario-US border (Ontario Ministry of Transportation), and annually the 401 carries over $1.2 trillion

Network

The five and a half million kilometers of asphalt-surfaced roads that make up North America's highway network have rendered the entire continent accessible to motorists, and have arguably been the single most instrumental factor in structuring settlement patterns and economic development during the last half century. The 1930s saw the beginning of the construction of this astonishingly efficient strategically engineered system, designed to optimize the logistics of mobility. The infrastructural matrix of the highway system now allows the rapid movement of goods and people throughout North America and supports the growth of a robust just-in-time production and distribution economy. Across the continent, the system's outward expansion is almost complete. While the twentieth century witnessed the establishment of this fine-grained distribution network and the production of ever more length, planners predict that the twenty-first will be defined by the consolidation of supersized, multicentered urban areas, where the sprawl-related growth and interconnection of proximate centers is creating the emerging *megaregions* of North America. This recently identified urban form is an agglomerated network of metropolitan areas with integrated labor markets, infrastructure, and land use systems that share and organize interdependent transportation networks, economies, ecologies, and culture (RPA 12; Goldfeld 4). The economic, transportation, ecological, and societal needs and dynamics of the megaregions are proving to be much more complex than a simple scaling-up of adjacent cities and systems. This appears to be a new species of human inhabitation. Indeed, we are on the eve of an era where

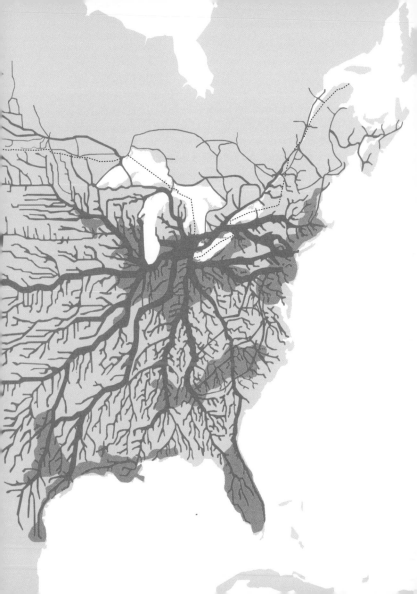

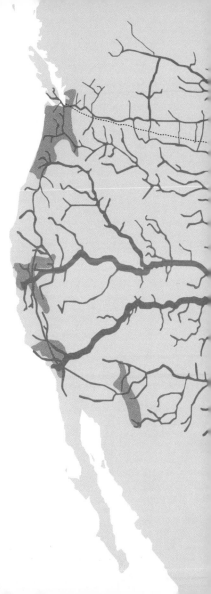

Transnational Freight Flows and Emerging North American Megaregions

"By mid-century, more than 70 percent of the nation's population growth and economic growth is expected to take place in extended networks of metropolitan regions linked by environmental systems, transportation networks, economies, and culture. These emerging 'megaregions' are becoming the new competitive units in the global economy, characterized by the increasing movement of goods, people, and capital among their metropolitan regions."

REGIONAL PLAN ASSOCIATION,
AMERICA 2050 PROSPECTUS

GEOFFREY THÜN
AND KATHY VELIKOV,
RVTR

ARBON
HWAY

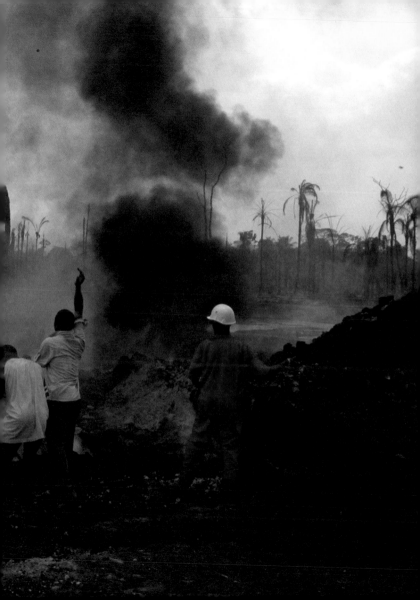

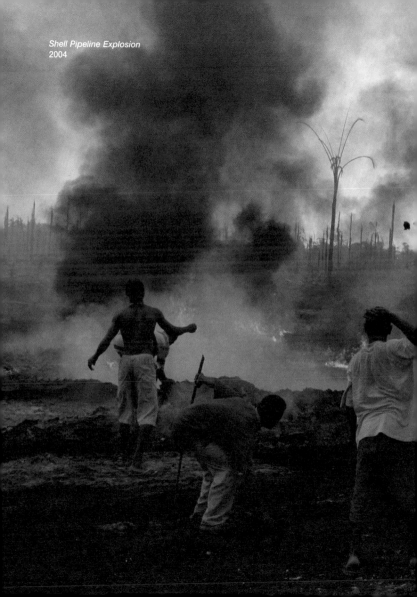

Shell Pipeline Explosion
2004

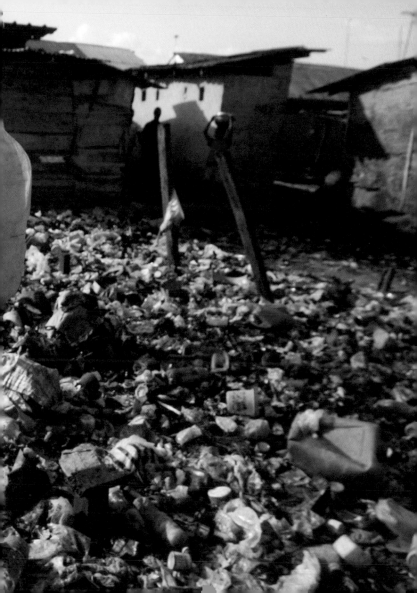

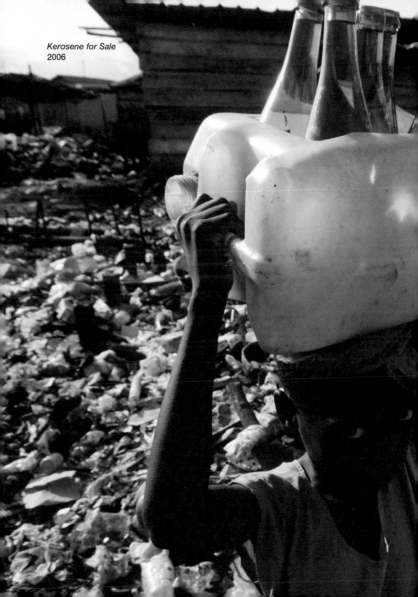

Kerosene for Sale
2006

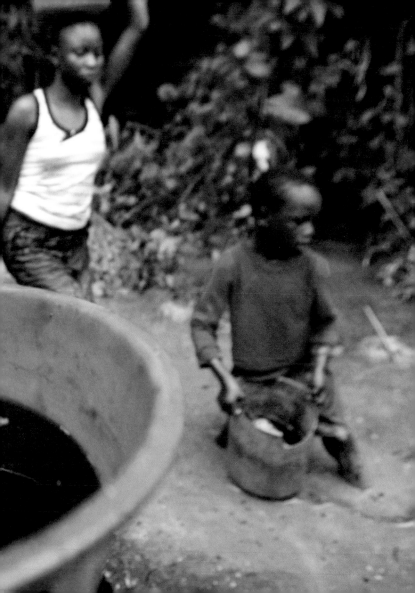

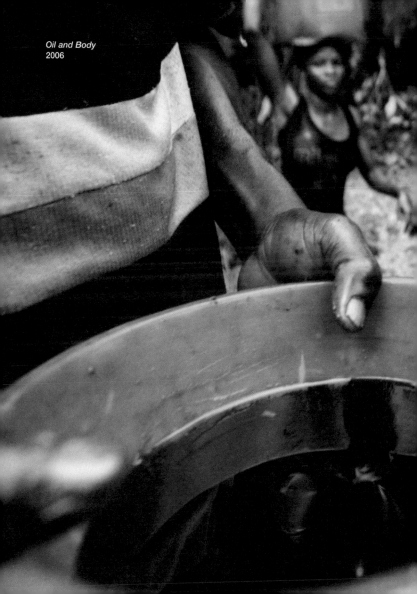

Oil and Body
2006

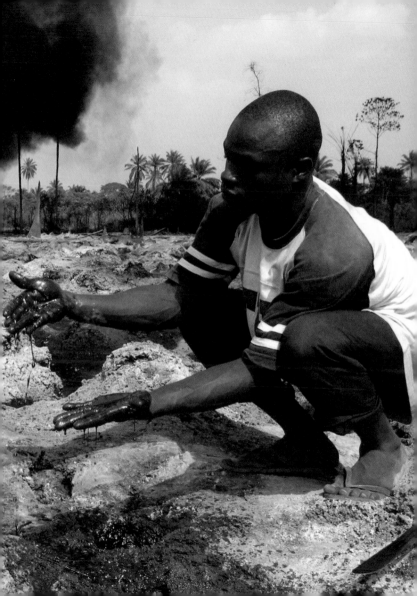

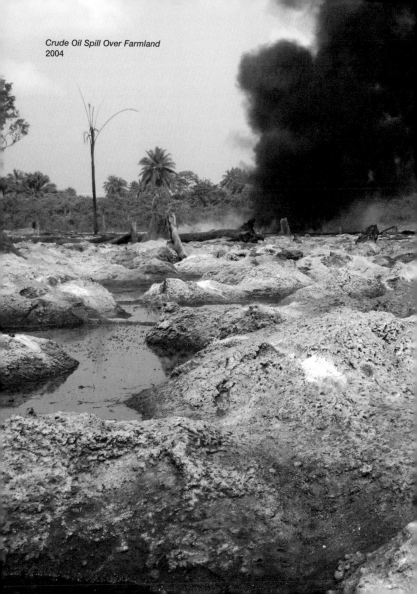

Crude Oil Spill Over Farmland
2004

Mending Net
2006

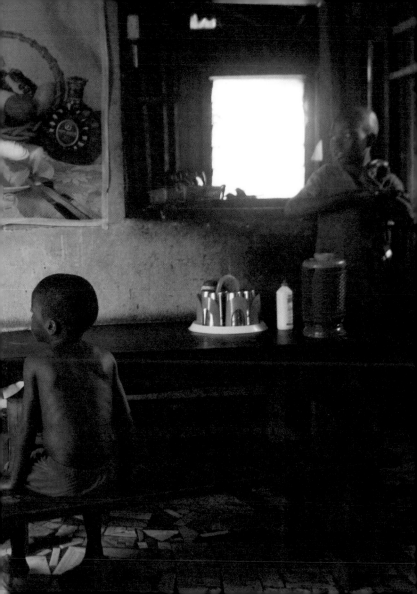

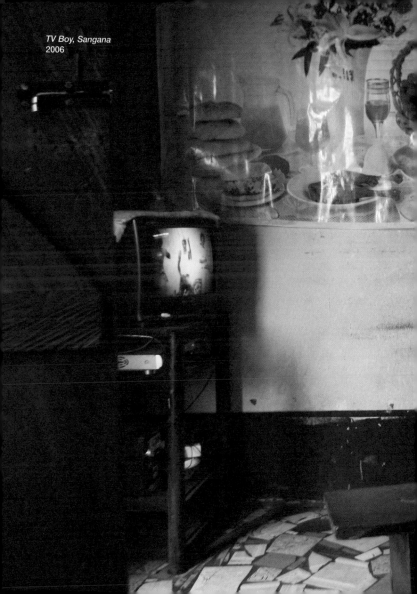

TV Boy, Sangana
2006

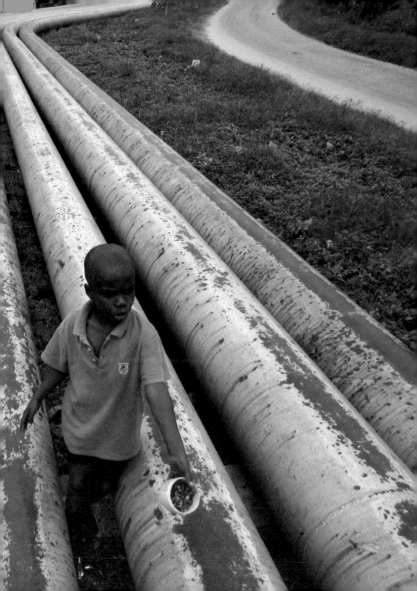

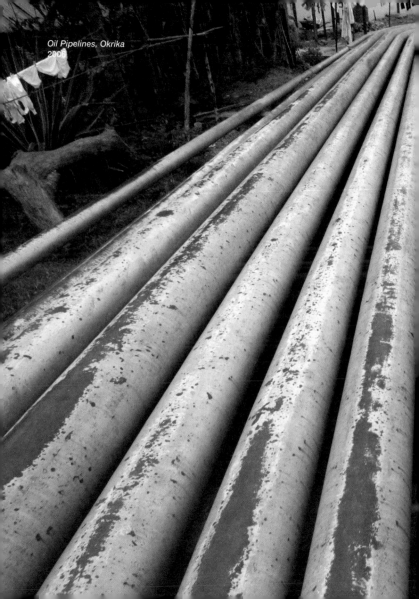
Oil Pipelines, Okrika
2006

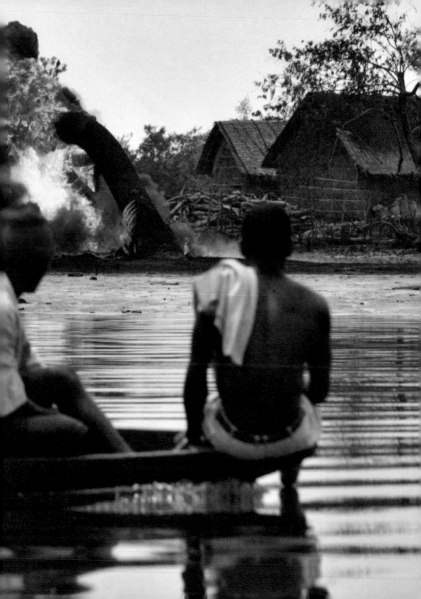

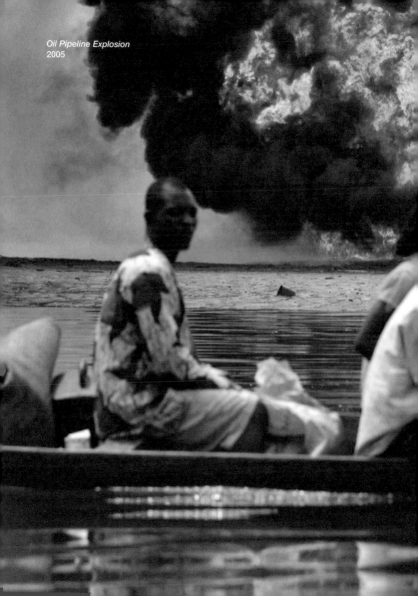

Oil Pipeline Explosion
2005

Akar Base
2006

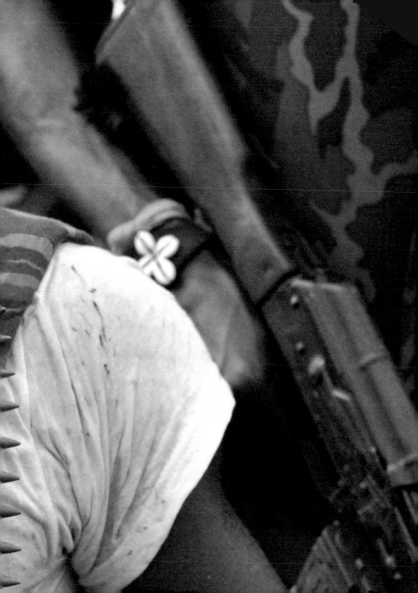

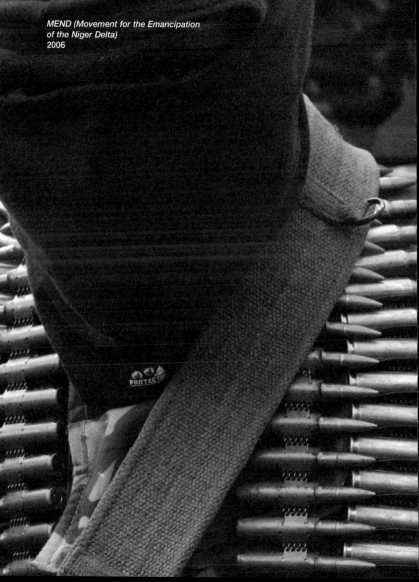

MEND (Movement for the Emancipation
of the Niger Delta)
2006

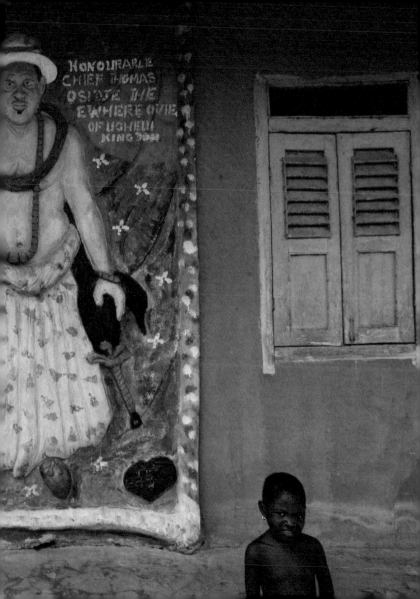

HONOURABLE
CHIEF THOMAS
OSIOJE THE
EWHERE OVIE
OF UGHELLI
KINGDOM

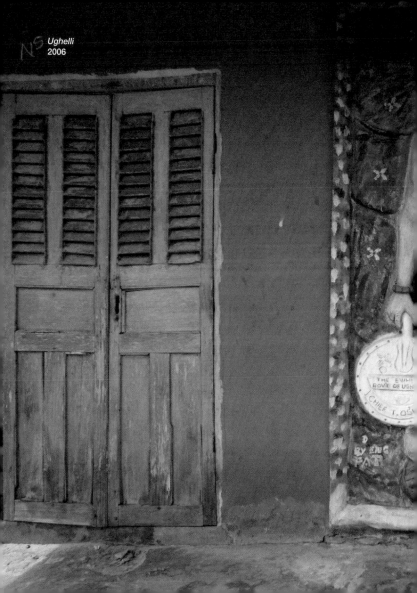

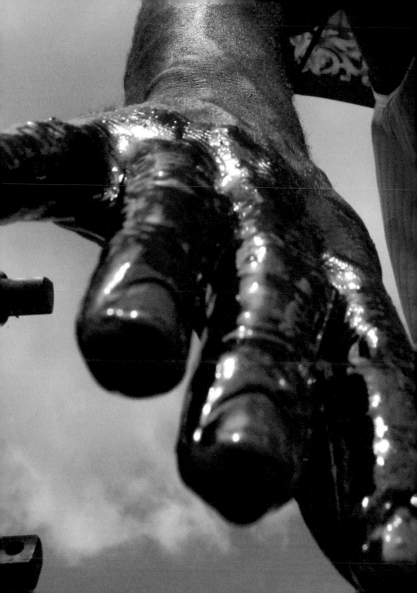

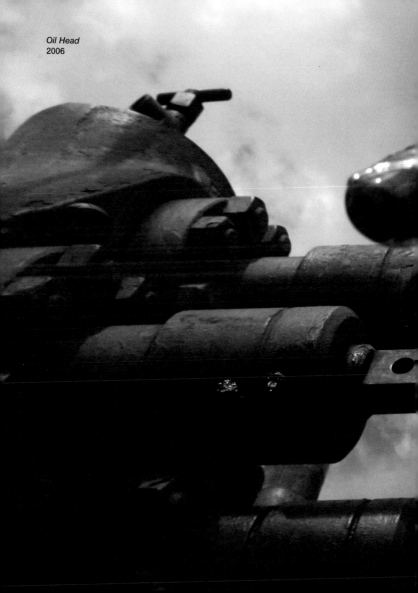

Oil Head
2006

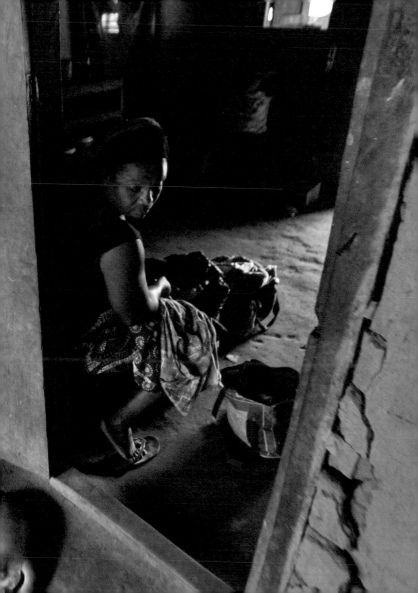

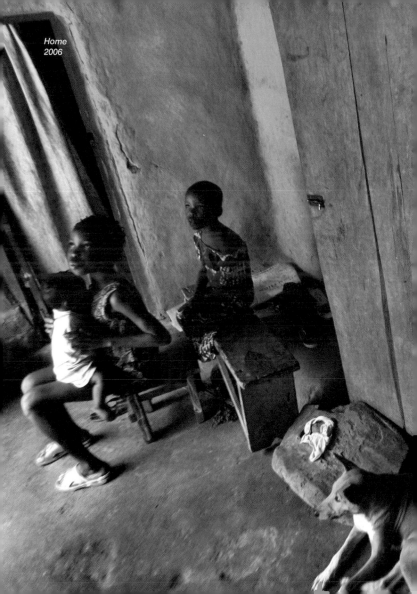

Home
2006

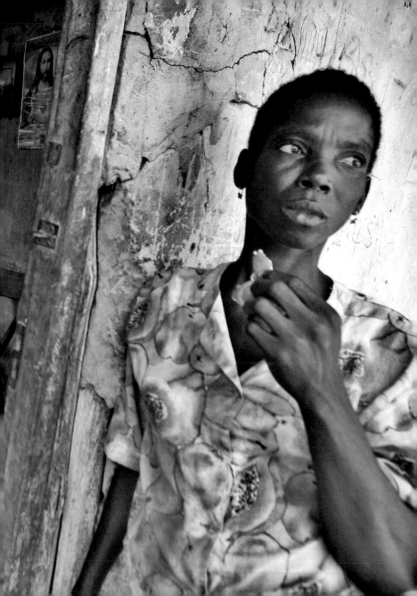

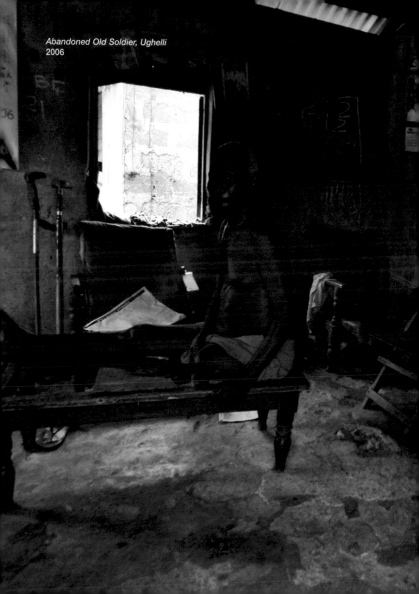

Abandoned Old Soldier, Ughelli
2006

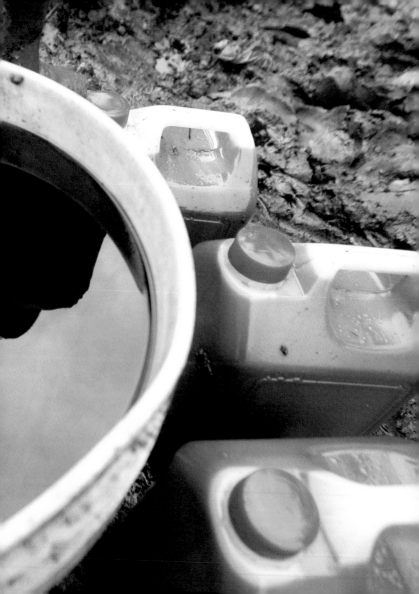

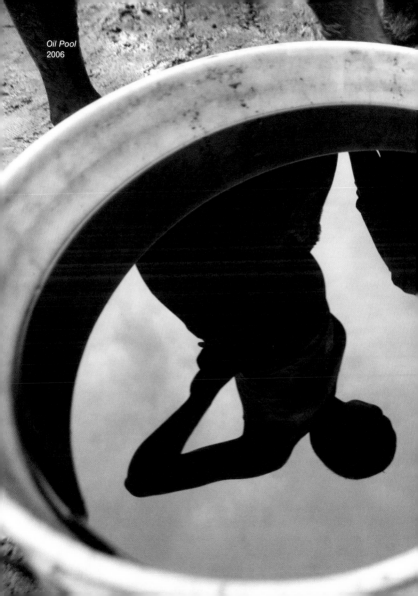

Oil Pool
2006

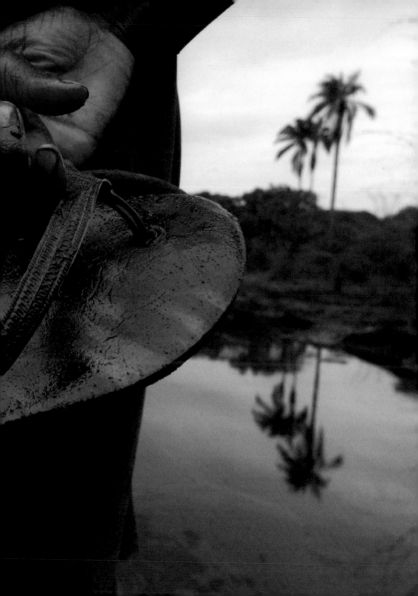

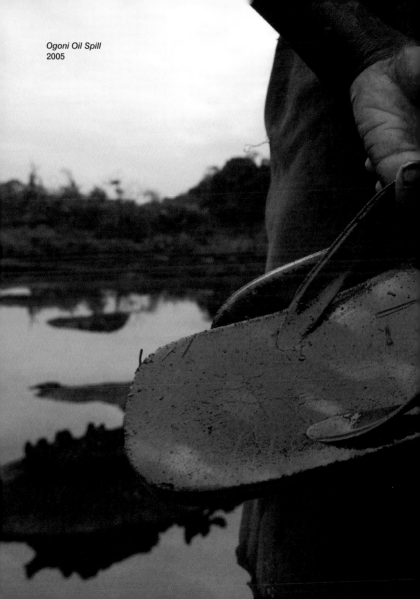

Ogoni Oil Spill
2005

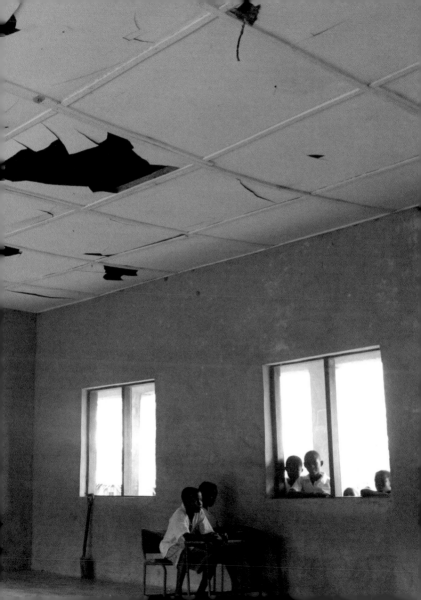

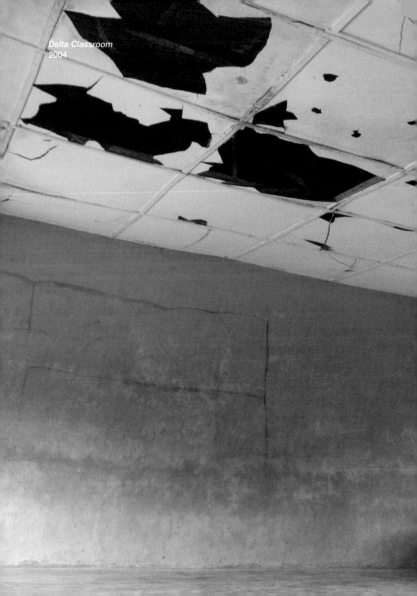

Delta Classroom
2004

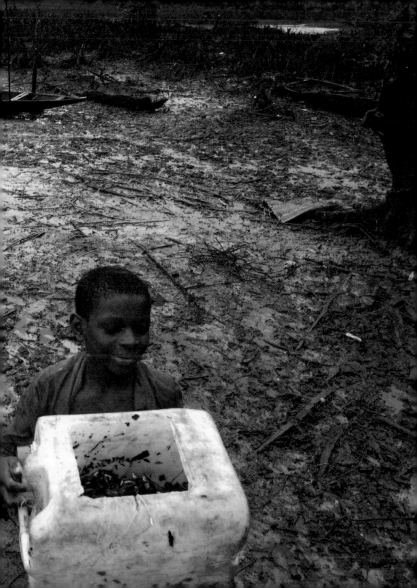

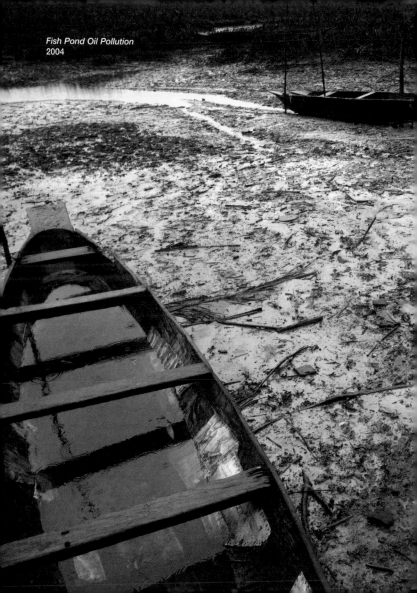

Fish Pond Oil Pollution
2004

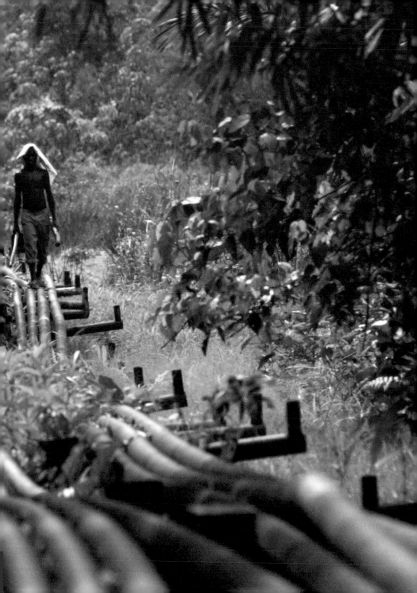

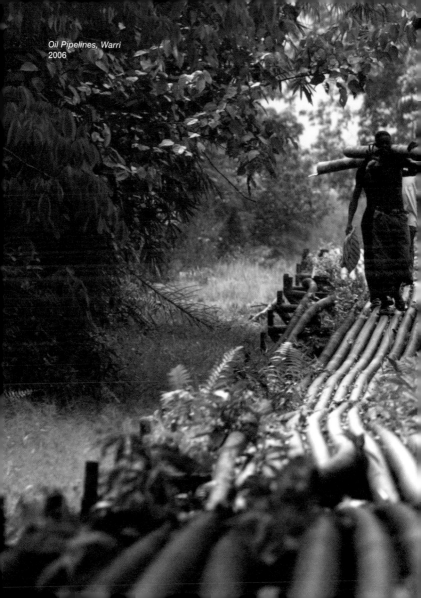

Oil Pipelines, Warri
2006

OIL
RICH

GEORGE
OSODI

NIGER DELTA

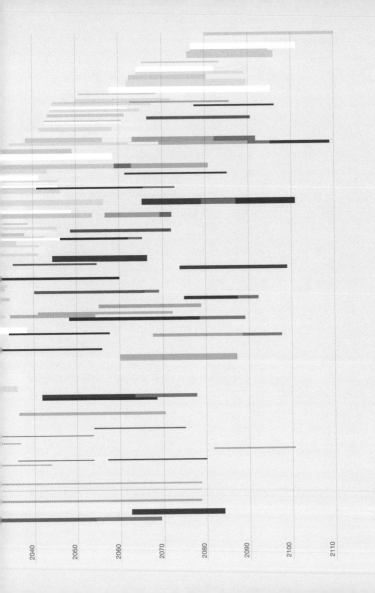

2040 2050 2060 2070 2080 2090 2100 2110

Post-Oil Reactivation: New resources, new activities.

Activity in the Caspian Sea, projected to 2100: as oil extraction declines, opportunities for alternative economies and ecosystems emerge.

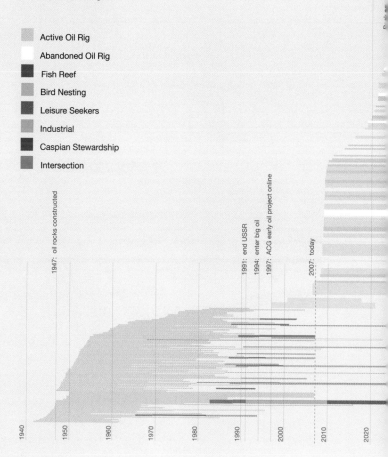

Active Oil Rig

Abandoned Oil Rig

Fish Reef

Bird Nesting

Leisure Seekers

Industrial

Caspian Stewardship

Intersection

1947: oil rocks constructed

1991: end USSR

1994: enter big oil

1997: ACG early oil project online

2007: today

1940 1950 1960 1970 1980 1990 2000 2010 2020

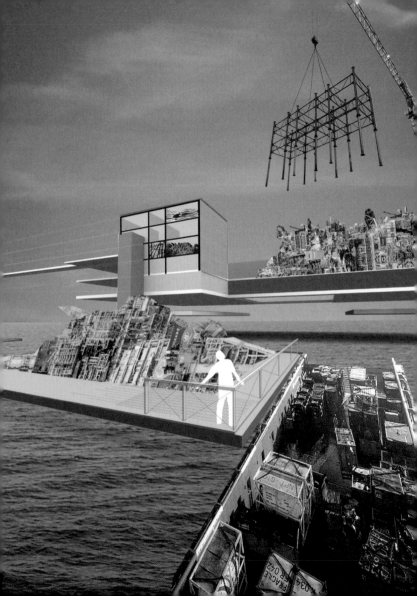

Reusing

The contested territory, effectively
uncontrolled, is a laissez-faire offshore
opportunity for entrepreneurs. The pres-
ence of abandoned structures, coupled
with the redevelopment of some rigs
towards new uses, provides a site for a
material exchange operation. The central
position of the territory, adjacent to the
waters of all of the littoral states, makes
it an ideal base for such activities.
Scavenged rig components, sorted and
traded, are reclaimed as resources.

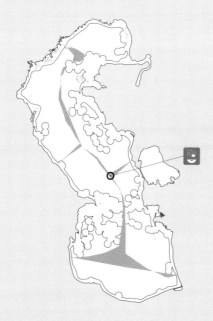

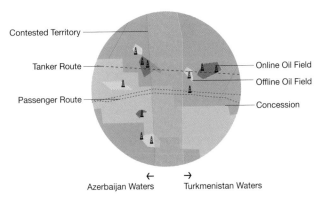

Contested Territory

Tanker Route

Passenger Route

Online Oil Field

Offline Oil Field

Concession

← Azerbaijan Waters

→ Turkmenistan Waters

Without any opportunities to switch transportation modes, the rigs neglect to take advantage of the already existing high speed ferry routes.

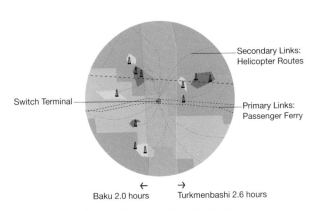

Secondary Links: Helicopter Routes

Switch Terminal

Primary Links: Passenger Ferry

← Baku 2.0 hours

→ Turkmenbashi 2.6 hours

New sea-based hubs allow passengers to transition from high speed and high volume to slower speed and more specific modes of transportation.

Redistributing

To promote a richer variety of lateral con-
nections between rigs, a system of switch
terminals is proposed along the median
zone of the sea. Placed at intersections
between this zone and passenger routes,
the terminals would serve as transition
points allowing passengers in high-speed,
high-volume vehicles to connect to
slower-speed, more specific modes of
transportation. Thus access is redistrib-
uted to include hub nodes within the sea
as well as the ones along the coast.

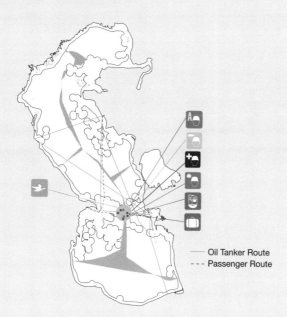

——— Oil Tanker Route
- - - Passenger Route

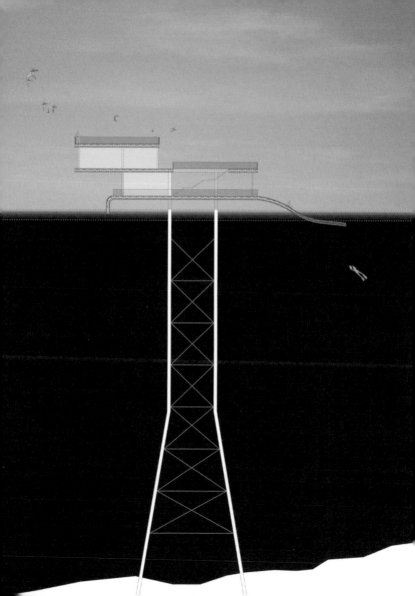

Reexploiting

The Caspian Sea currently represents the
frontier of oil exploration and exploitation.
It is projected that oil extraction will peak
between 2020 and 2030. When the oil
companies begin to wind down their oper-
ations, the key to the proposed renewal
of the sea will be the reexploitation of
the relics they leave behind. Here, a small
offline oil platform, abandoned in the 1960s,
has been transformed into a node along
a network of bird-watching and dive sites.

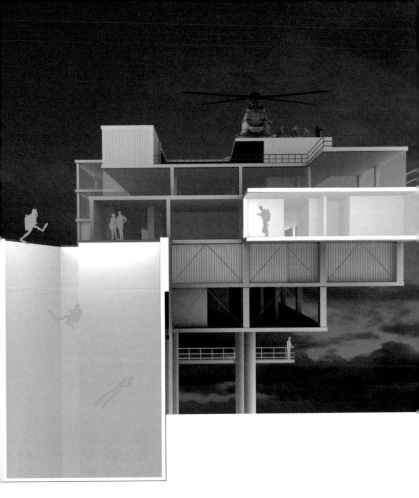

Reoccupying

Sparsely dotted over the vast sea, the constructed surfaces of the rigs are at a premium. In order to increase the occupiable area, the rig's floors are offset. As wildlife and human populations shift and diversify, it is expected that the scarce but valuable surfaces will attract new occupants. This offline oil extraction platform is transformed into an accommodation and gateway unit for leisure and adventure seekers.

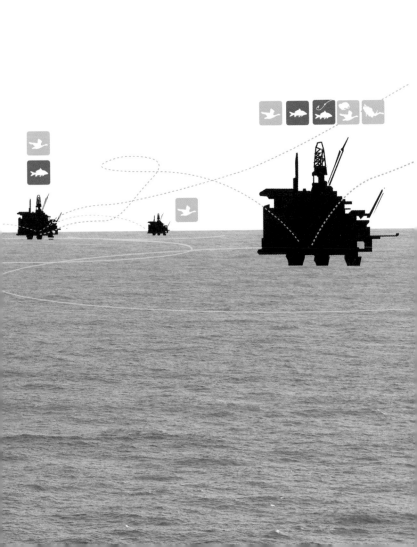

Renetworking

The organizational strategy for operations currently emerging in the Caspian Sea is primarily a hub-and-spoke model. Satellite oil operations are directly connected back to the major ports on the shore, Baku and Turkmenbashi. As activity in the open water increases, connections between rigs are amplified and the strategy is modified; the lines of contact back to the ports become less significant.

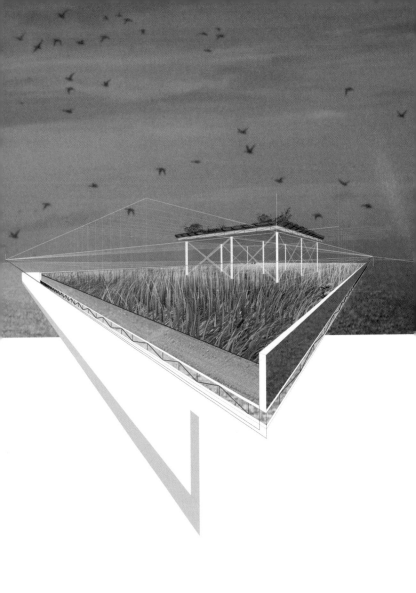

Reactivating

The relationship between the occupiable surface offered by the abandoned rigs and the territories of the sea's occupants becomes more evident as years pass. The development that followed the building of the rigs rendered parts of the shoreline inhospitable to water birds, but a less obvious result of the human incursion is that the now deserted structures have begun to offer birds and fish new habitats—expanding their territories' bounds. The birds have begun to fly from rig to rig during their migration, avoiding contact with the shore altogether. The abandoned rigs offer similar habitats for fish by simulating reef-like conditions that attract nutrients for the fish. This type of reactivation is already taking place; this site, located at a convenient location on the migratory flyway, offers a resting place for passing birds.

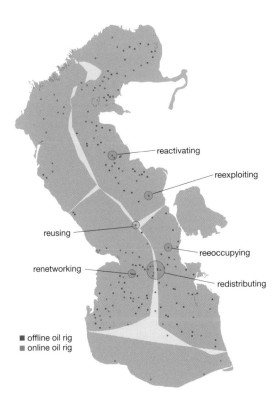

reactivating

reexploiting

reusing

reeoccupying

renetworking

redistributing

■ offline oil rig
■ online oil rig

Six sites were chosen to highlight post-oil opportunities in the sea. Sampled to represent diverse complexities, proximities and scales, the sites will begin redevelopment in 2030 after oil operations have peaked. Newcomers, identifying vacant niches, move in to supplement the existing occupants.

POST-PEAK ADAPTATIONS: NEW PLAYERS AND REDEFINED SITES

Existing Occupants

 oil workers

 fish workers

water birds

fish

New Occupants

 Caspian stewards

 tourism workers

 leisure / adventure seekers

 maverick entrepreneurs

Fish

The life of sturgeon is divided into three
phases. Spawning takes place in the
spring in the freshwater rivers feeding
the sea; the fish then spend most of the
year feeding in the shallower northern
regions; and in the winter they move
south to warmer waters.

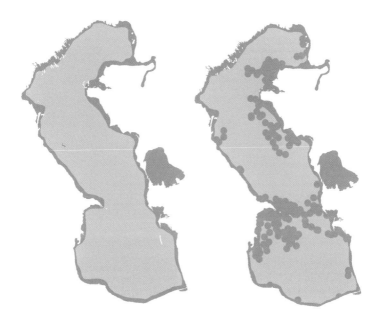

Birds

Base Territory (before oil operations)
Water birds typically keep a maximum 15km flying distance from occupiable surfaces. Without any surfaces in the sea, the birds' territory is a 15km wide band from the edge of the sea.

Expanded territory (2030)
As rigs offer occupiable surfaces within the sea, the birds' territory expands.

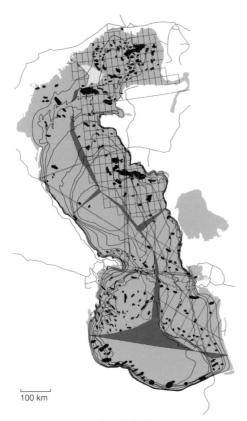

100 km

The Caspian as seen through the filter
of oil operations: concession systems,
contract blocks, pipelines, tanker
ports and routes, national boundaries,
bathymetric and climatic conditions,
and the oil fields themselves.

Three strata, three players: oil, fish, and birds

Each of the air, water, and ground volumes has a unique set of occupants. The birds occupy the sky, the fish occupy the water, and the oil operations span across all three.

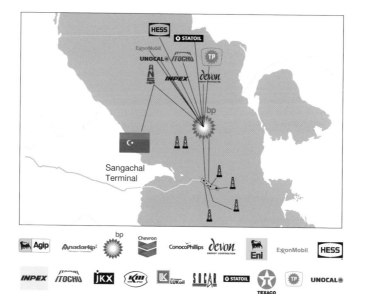

Littoral nations lease individual concessions to multinational oil companies. Currently there are five nations and more than twenty major oil companies vying for positions within the sea.

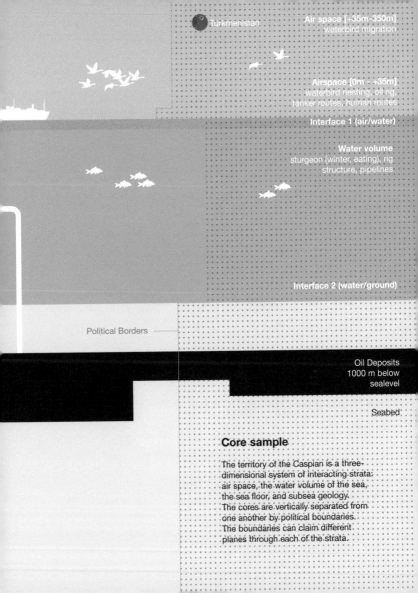

Turkmenistan

Air space [+35m-350m]
waterbird migration

Airspace [0m - +35m]
waterbird nesting, oil rig,
tanker routes, human routes

Interface 1 (air/water)

Water volume
sturgeon (winter, eating), rig
structure, pipelines

Interface 2 (water/ground)

Political Borders

Oil Deposits
1000 m below
sealevel

Seabed

Core sample

The territory of the Caspian is a three-
dimensional system of interacting strata:
air space, the water volume of the sea,
the sea floor, and subsea geology.
The cores are vertically separated from
one another by political boundaries.
The boundaries can claim different
planes through each of the strata.

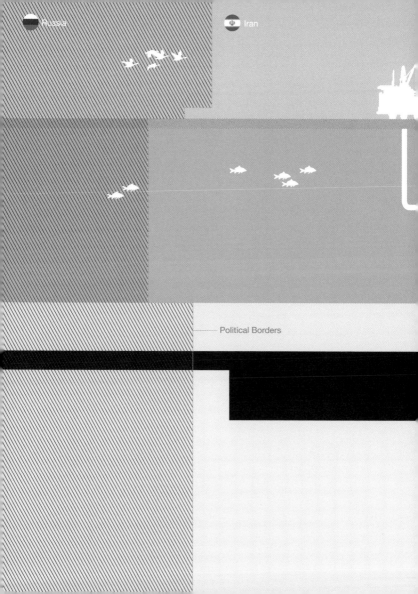

Russia Iran

Political Borders

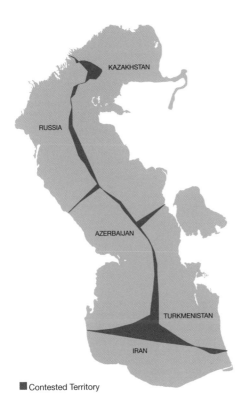

■ Contested Territory

Post-Soviet
territorial division

After the fall of the USSR, three new
nations emerged. Differing interpretations
of maritime law by the littoral states
created a contested zone along the
sea's median.

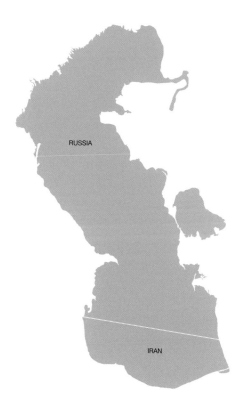

RUSSIA

IRAN

Territorial division
before 1991

The Caspian was divided between
the two littoral, or shoreline-occupying,
nations: Iran and the USSR.

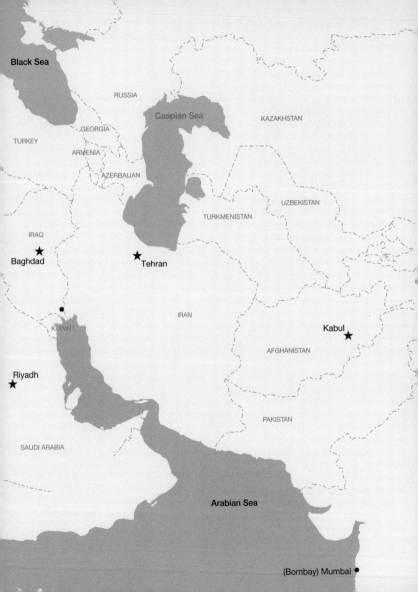

post-oil phase of the sea, rather than passively anticipating a post-industrial wasteland?

Other inhabitants of the sea have already begun to make use of the abandoned Soviet infrastructure, according to their own purposes. Water birds are one such population. The western coast of the Caspian is a major flyway, supporting the migration of more than 20 million water birds each year. Typically these birds stay close to the shore, within fifteen kilometers of a landing. As development has destroyed their habitat along the coast, many birds have claimed abandoned oil rigs as resting points along their routes.

The oil rigs have also created new territory for Caspian fish. The sea is home to a variety of fish species, including sturgeon, from which more than 90 percent of the world's caviar is harvested. As inland spawning grounds and coastal habitat are degraded by development and poaching, the offshore oil installations have become an important alternative sanctuary. Acting as artificial reefs, the structures provide surfaces that support the growth of plant life, which in turn supplies food for the fish. Taking our cue from the adaptations of these existing sea-dwellers, we can and should develop a strategy for post-oil reactivation of the Caspian, a Hundred (or Thousand) Year Plan that identifies potential new resources and establishes activities that will form the basis for the ongoing occupation of the sea.

The world's first offshore oil platform was built in the Caspian in 1947, but by the 1960s the Soviet regime had abandoned extraction in the region, focusing instead on newer, more easily exploited oil fields. After the Soviet collapse in 1991 the sea abruptly became available to outsiders again, and a diverse collection of major and minor actors began to stake their claims.

Before any of the potential riches of the Caspian's seabed can be realized, however, legal rights to the sea and the oil beneath it have to be resolved and redivided among the new claimants. The prize under dispute is not a simple territorial surface but a three-dimensional, four-level system: the air space over the sea, the water itself, the sea floor, and the subfloor geology with its sought-after reserves of trapped petroleum. To further complicate matters, the Caspian does not fall neatly into any one category recognized by maritime law: it is inland and isolated from the world's ocean systems, like a lake, but its water is salty (though less saline than a full-fledged sea). Each of the five parties is pressing the interpretation that favors its own interests, creating zones of contested territory at the intersections of each nation's waters.

Whatever the outcome of these disputes, one thing is certain —the resource will be exploited. Rigs will be installed, pipelines will flow, and the oil will be sold. Yet even as this process moves inevitably forward, it is also becoming clear that the petroleum economy and its associated operations will have a limited lifespan. Beyond that moment when the last barrel of oil leaves the seabed, the Caspian will remain. Is it possible to plan for this moment by extending the momentum generated by the oil operations into the

The Caspian Sea, the largest inland body
of water in the world, lies at the center of a
turmoil of shifting global powers. Since
the dissolution of the Soviet Union, three
new states—Turkmenistan, Azerbaijan and
Kazakhstan—have been created on the
shores of the Caspian and asserted their
claims to territorial waters that were once
divided, by a settled agreement, between
Russia and Iran. What all five countries
are hoping for is secure access to a largely
untapped reservoir of oil beneath the
seabed. Nor are they the only interested par-
ties; the United States, the European Union,
multinational oil companies, international
financial institutions, and nationalist political
movements are also eager to exploit the
opportunities the Caspian offers.

OCCUP THE CA SEA

A ONE HUNDRED YEAR PLAN

MAYA
PRZYBYLSKI

Dubai's Palms and World produce a hallucinogenic post-peak leisure land. No place on earth can lay claim to such ambitious utopian projects, at such a massive scale, as these two. And this is how they should be confronted, within the lineage of the cultural production of utopia. Utopia is not necessarily a place that all would seek to inhabit. In fact, as here, utopian imaginings can often be the result of fantasy on overdrive, reaching a condition simultaneously alluring and repulsive.

entire adjoining seabed topography to the dredgers. This guidance, combined with GPS technology, allows the drivers to deposit sand in precise locations relative to palm tree or world map layouts. In the end something designed from above is built from above, through locative data and surveying systems.

Slowly and steadily islands rise to the surface, in a process halfway between Smithson-like "aerial art" and a kind of free-wheeling pop urbanism. Simultaneously inviting and mysterious, Nakheel's developments exhibit a Koolhaasian "bigness," but without dependence on the small-scale technical infrastructure of elevator, steel, and air conditioning. Instead these fantasy islands are a product of the infrastructure of global tourism, global positioning systems, and land-moving technology. Like Koolhaas's escalator or HVAC, these are all mechanisms in their own right, though operating at a scale bigger than "bigness."

With six million visitors a year, Dubai has emerged as one of the fastest-growing holiday destinations in the history of the travel business, a global hot spot for the information age. Lessons learned in Miami, Las Vegas, and the Netherlands are in the next stage of their evolution here on the Gulf coast. In many ways, the physicality of Dubai is less important than the idea of its physicality.

III: CONCLUSION: NEW UTOPIAS

The urbanisms fueled by hydrocarbons in Russia and the United Arab Emirates are two extreme examples of evolving city-forms ultimately presenting new forms of utopia. Russia's Sakhalin and Shtokman fields yield a utopia of infrastructure and connectivity.

meters (and costing an average of $15 million apiece) is a mutant miniaturization of countries as islands, allowing the purchaser to conflate the owning of land with owning a nation. This act of dividing the land from the sea also serves to edit our real world, taking liberties with the shape of certain countries while omitting others entirely; there is no Israel in this "World" and no Northern Ireland either—too politically loaded for an oasis. By some counts the combined reclamation of The Palms, The World, and The Waterfront accounts for 2.5 billion cubic meters of rock and dredged sand. Taken together, projects like the recently completed Palm Jumeirah have added sixty kilometers of coastline to the Persian Gulf.

But who would be capable of such a massive land and marine engineering project? Who but the Dutch? A marine contracting company called Van Oord that specializes in dredging was hired in 2001 for The Palm Jumeirah. Since then, Van Oord has had a fleet of dredgers in Dubai working twenty-four hours a day. The primary equipment is the trailing suction hopper dredger, which allows the fleet to move 200,000 cubic meters of sand every day. Since the water can be up to 11 meters deep, the first sand deposits are unloaded through a base hatch. The remaining sand is moved by a machine that spits an arc of filtered sand through the air, in a process called "rainbowing," to the desired location, until the land surface appears above sea level. For The Palm a perimeter breakwater was established first, to protect the potentially fragile "fronds" of the palm tree as they were built up.

Every twenty-four hours a boat equipped with a sophisticated multi-beam echo sounding system issues a fresh survey of the

states on its website, they offer "a portfolio that redefines home, holiday, and investment."

Five developments—"The World," with manmade islands as a map of the world, each in the shape of a country; "The Waterfront," a series of massive arcing islands and three versions of "The Palm," peninsulas branching out like fronds—perfectly exemplify the Dubai aesthetic. In name alone, each commands an authoritative, there-is-only-one singularity; the *The* in their designations signifies the branding. With every flight into Dubai, passengers are treated to an aerial spectacle, descending toward a stage set with choreographed advertisements for the lifestyle of these developments. And the palm shape? Well, what could better represent the collective unconscious of oases and paradise urbanism than a palm tree?

The palm figure combines a "trunk" of infrastructure and amenity with residential "fronds" wide enough for double-loaded housing, staggered far enough apart for sea-based cul-de-sacs, with a private beach extending from each house like a sandy lawn. "The Palm Deira," at 80 square kilometers, is the size of Greater London, and larger than Paris or Manhattan. Yet Deira offers only eight thousand villas. What matters is not density but exclusivity, not urban planning but living in a post-card. "The Palm Jumeirah" project has become so enormous that low-paid laborers have been living offshore in cruise ships during construction in order to avoid traffic congestion on the one bridge that provides access to the site.

The World's re-creation of, well, the world, as a series of private customizable island plots ranging from 23,000 to 83,000 square

THE PALM - JUMEIRAH
2001–2004
78 km OF NEW COASTLINE
92,234,000 CUBIC METERS OF SAND

THE PALM - JEBEL ALI
2002–2008
230,000,000 CUBIC METERS OF SAND

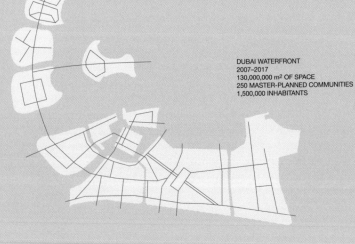

DUBAI WATERFRONT
2007–2017
130,000,000 m² OF SPACE
250 MASTER-PLANNED COMMUNITIES
1,500,000 INHABITANTS

Slick Cities: Dubai
Island Privatopia Typology

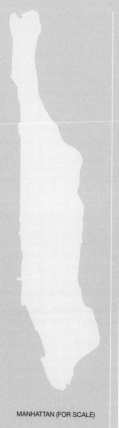

MANHATTAN (FOR SCALE)

0 2km 4km

THE WORLD
2003–2008
300 ISLANDS
232 km OF NEW COASTLINE
320,000,000 CUBIC METERS OF SAND

	Land
—	Main Roads
	Commercial
	Mid-density
	High Density
	Estate
	World Resorts
	Entrys

THE PALM - DEIRA
2003–2013
1,140,000,000 CUBIC METERS OF SAND
47,000,000 TONNES OF ROCK

colonies. Unreality mixed with familiarity is part of the scheme, and it is not always successful. For example, an indoor ski slope called Ski Dubai – its ability to entice tourists notwithstanding – is rumored to reek of Freon.

Dubai's zones serve mostly as bookmarks for future investors as they test the waters of development experiments such as Dubai Aid City or Dubai Outsource Zone. Almost arbitrarily, one plot of sand is designated for sports and another for media. Combining the programmed leisure of the megaresorts of Las Vegas with the pop aesthetic of Tokyo, Dubai generates a mirage of place within a car-fueled desert suburbanism.

Island Urbanism: Fabricating Land

When potential buyers consider a Dubai purchase there is often no physical land for them to view. They are buying the idea of land the way they buy an idea of lifestyle. Land is engineered in Dubai, as developers freely manufacture new islands and peninsulas, shifting rock and sand to replace the sea, and creating lagoons, canals, and marinas where there once was land. Unlike Holland, Dubai manufactures land through dredging rather than draining; their enterprise is additive rather than subtractive.

Dubai's true urban innovation, despite all its fantasy themes, is more its production of land than architecture. Sand and sea seem to be switched at will. Probably most significant are the land reclamation and dredging projects of Nakheel developers. These island-based residential projects offer a manufactured suburbanism, or a romanticized version of living offshore. As Nakheel

certainly not interested in urban centers. Enclaves are an incomplete idea that does not need finishing.

In Dubai's residential enclaves, internal patterns reference only themselves. Figure and ground are interchangeable. Ground is as much figure as built mass. They are not unlike North American gated suburban communities, but here the gate is water or desert or superhighway. Each zone is a sterile mini-city with clichéd nomenclature, such as Jumeirah Village, Emirates Living, and Discovery Gardens, and each offers a generic but competitive list of amenities such as waterfront property, golf, and themed gardens. Though culturally and geographically deracinated, each zone acquires identity through "theme," which is the lifeblood of this form of urbanism.

Business enclaves behave similarly though at a larger scale. Here too there is a resemblance to the retail corridors of exurban North America. These commercial zones group their facilities in campus-like clusters, avoiding ambiguity with such blatant and Calvino-esque names as Knowledge Village, Healthcare City, Media City, Internet City, or Sports City. The brochure for one development called "Lost City" sums up this blending of theme and branding best when it claims it is "inspired by famed cities in Arabian history and combines this with the best of modern amenities."

Enclaving is also about imagineering familiarity. For example, Dubai International City zone contains a life-size replica of the Forbidden City. Developers are simulating an "off-world" of global familiarity, placed somewhere between the manufactured cities of the game SimCity and Philip K. Dick's off-Earth

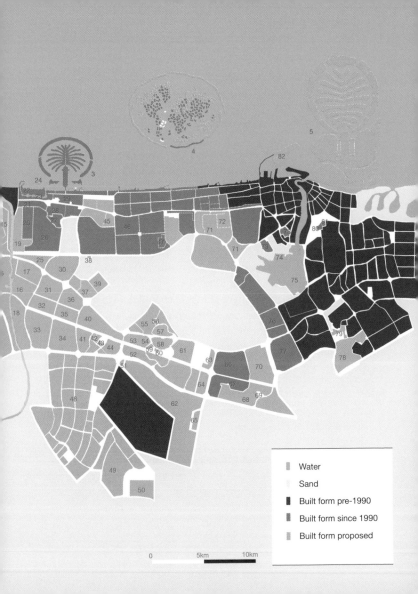

	Water
	Sand
	Built form pre-1990
	Built form since 1990
	Built form proposed

0 5km 10km

Slick Cities: Dubai
Enclaving

1 DUBAI WATERFRONT
2 THE PALM JEBEL ALI
3 THE PALM JUMEIRAH
4 THE WORLD
5 THE PALM DEIRA
6 MR TECHNOLOGY PARK
7 DUBAI INDUSTRIAL CITY
8 JEBEL ALI AIRPORT CITY
9 DUBAI AID CITY
10 DUBAI INVESTMENT PARKS
11 GREEN COMMUNITY
12 THE LOST CITY
13 THE GARDENS APARTMENTS
14 THE GARDENS SHOPPING CNTR
15 DISCOVERY GARDENS
16 GULF ESTATES
17 INTERNATIONAL MEDIA ZONE
18 JEBEL ALI BUSINESS CENTRE
19 JUMEIRAH VILLAGE NORTH
20 JUMEIRAH ISLANDS
21 JUMEIRAH LAKE TOWER
22 JUMEIRAH BEACH RESIDENCE
23 DUBAI MARINA
24 HYDROPOLIS HOTEL
25 JUMEIRAH VILLAGE TRIANGLE
26 EMIRATES SPRINGS
27 EMIRATES HILLS
28 EMIRATES GOLF CLUB
29 DUBAI PEARL
30 JUMEIRAH VILLAGE CIRCLE
31 DUBAI SPORTS CITY
32 OUTDOOR SPORTS
33 GULF CITY
34 LOW DENSITY COMMUNITY
35 STUDIO CITY
36 MOTOR CITY
37 ATHENOPOLIS
38 THE SCHOOLS
39 DUBIOTECH
40 ARABIAN ESTATES
41 HIGH INCOME COMMUNITY
42 DUBAI LIFESTYLE CITY
43 TAALEEM BEACON EDUCATION
44 PLANTATION EQUESTRIAN POLO CLUB
45 AL BARSHA DEVELOPMENT
46 LABOR CAMPS
47 AL GOZE LAND
48 DUBAILAND
49 TIGER WOODS DUBAI
50 DUBAI HERITAGE VISION
51 ISLAMIC CULTURE & SCIENCE WORLD
52 THE VILLAS
53 GLOBAL VILLAGE
54 AQUA DUBAI
55 LEGENDS
56 BEAUTY LAND
57 THE CITY
58 CITY OF ARABIA
59 DUBAI BAZAAR
60 ASTROLAB RESORT
61 FALCON CITY OF WONDERS
62 THEME PARK CITY
63 FRISCO RIDGE
64 DUBAILAND RESIDENTIAL COMPLEX
65 DUBAI OUTLET CITY
66 DUBAI SILICON OASIS
67 ACADEMIC CITY
68 KNOWLEDGE VILLAGE
69 DUBAI OUTSOURCE ZONE
70 HEAVY EQUIPMENT & TRUCKS ZONE
71 DUBAI BUSINESS BAY
72 BURJ DUBAI MALL
73 DUBAI HEALTHCARE CITY
74 ARABIAN BAY
75 DUBAI FESTIVAL CITY
76 DUBAI FRUIT & VEGETABLE MARKET
77 INTERNATIONAL CITY
78 DUBAI ZOO
79 MIRDIF GATE
80 DUBAI CARGO VILLAGE
81 DUBAI FLOWER CENTRE
82 MARITIME CITY

Enclave Urbanism: Resorts

Will the Dubai experiment prove to be a model for other oil-rich countries anticipating post-peak fallout? And will its rapid transformation from industrial modernity to an international corporate/leisure destination be successful? Arguably the world's first de novo urban brand writ large, Dubai, the idea, is taking shape right now. Radically fusing free zones, extreme leisure, and an investor's dream, Dubai already had tax-free status, low inflation, and a high standard of living. In 2002 its offerings as economic haven were enhanced when its rulers decreed that foreigners would be legally entitled to own freehold property, and purchasers would be granted visas as permanent visitors. There is no precedent for this anywhere on the globe. Intoxicated by this open invitation, leisure-seekers and global-minded businesses alike have flocked to this desert city on the Persian Gulf.

An early project, the construction in 1985 of the Jebel Ali Free Zone port, with the world's largest man-made harbor, gave Dubai an identity as a staging place for some 4,000 companies, from 100 countries, looking to gain access to the growth markets of Asia. Since that time, developers such as Emaar and government-owned Nakheel have concentrated and reterritorialized desert land to build micro-cities serving emerging global businesses. This has spawned an entirely new kind of international urbanism that combines offshoring with programmatic enclaving in some forty-odd tax- and duty-free oases puzzled together. However, enclaves are not interested in their edges, and are indifferent to the extent of territory they cover. Enclaves are

II: SLICK CITIES

Intense urbanization in countries across the Middle East has given rise to several unique urban morphologies with regard to scale, land use, and lifestyle. In the United Arab Emirates, the city of Dubai stands out as an example of a newly articulated urbanity. Oil was discovered in Dubai in 1966, and petrodollars funded the modernization of the emirate. However, the oil reserve, not that substantial to begin with, is due to expire in 2010. A shrewd business maneuver by Dubai's ruler, Sheikh Rashid bin Saeed al-Maktoum, is repositioning the city-state as a service- and tourism-centered economy based on a series of enclaves combining business with luxury, artifice with natural splendor, and excess with amenity. The growth of contemporary urbanism here is not about density or practicality: it is unabashedly about fantasy and the luring of international trade and tourism. Roughly $100 billion worth of projects are either underway or planned.

Dubai posits the post-oil city as a dizzying mix of oases, constructed islands, megatowers, and industry-specific zoning. It has faith in superlative urbanism: tallest tower, largest retail development, biggest man-made harbor, fastest-growing airline, largest land creation/reclamation projects, and the most imaginative branding of urban zones as micro-cities. In one of the largest urban investment risks of recent history, Dubai is zealously engineering artificial islands, techno-enclaves, and extensive leisure infrastructure.

complete setup in 2008, Sakhalin II will be the largest oil and gas field in the world.

Gazprom City

A controversial third new Russian urban development project—more city than infrastructure—was recently proposed by Gazprom. In November 2006 the company announced an architectural design competition and invited international firms to submit visions for a large complex, centering on new headquarters for Gazprom, to be built in St Petersburg, a city whose center is a UNESCO world heritage site. The winning design came from the London-based firm RMJM, one of six entrants. The project envisions a dense 77-hectare enclave of administrative buildings surrounding a 369-meter skyscraper complete with concert halls and shopping centers. The fact that the tower would be three times the height of the nearby historic Smolny Cathedral was considered unacceptable by many of the competition jurors, who subsequently walked out in protest. More recently, even UNESCO has requested that Russian authorities halt construction. In an attempt to fend off negative publicity, Gazprom and RMJM have announced that the construction of the tower will be at the forefront of sustainability. Putting on a good face in the big city while rampantly developing resource fields, Gazprom's image as the Kremlin's cash cow seems even more assured by the recent successful presidential candidacy of Dmitry Medvedev, previously chair of the board at Gazprom.

temperatures, *Yastreb*'s crews are able to work even in midwinter conditions of thick ice cover. Complementing *Yastreb* is *Orlan*, a twenty-well concrete structure serving as the offshore drilling and living quarters for Sakhalin I. There is also an onshore facility that processes the oil and gas, which are then moved 637 kilometers south to a distribution port in Prigorodnoye.

Prigorodnoye, the distribution site, was a small village just 13 kilometers east of the town of Korsakov that has now been entirely subsumed into the business of Russia's first foray into liquefied natural gas (LNG) processing. LNG, with its greater density, boasts increased efficiency for storage and transport. Tankers access the processed goods from two loading arms on an 805-meter jetty into Aniva Bay. At peak Prigorodnoye will service about 160 LNG carriers and 100 oil tankers each year, or one every two days.

During Phase 1 of the Sakhalin field development in 1998, the *Molikpaq* offshore platform was installed. A converted Canadian drilling rig that was first used in the Beaufort Sea, the *Molikpaq* was towed across the Pacific Ocean to Korea where it was upgraded for Sakhalin II. *Molikpaq* was retrofitted with a steel spacer that allows it to better handle the deep waters off Sakhalin. About 150 people can live and work on *Molikpaq* as it is now, but two new platforms, *PA-B* and *LUN-A*, to be added in 2008, will each accommodate about 100 additional staff members. With autonomy similar to that of micronations, these rigs act as small company islands. These floating company quarters will be engineered with friction pendulum anti-earthquake bearings, safety technology commonly used in California. Expected to

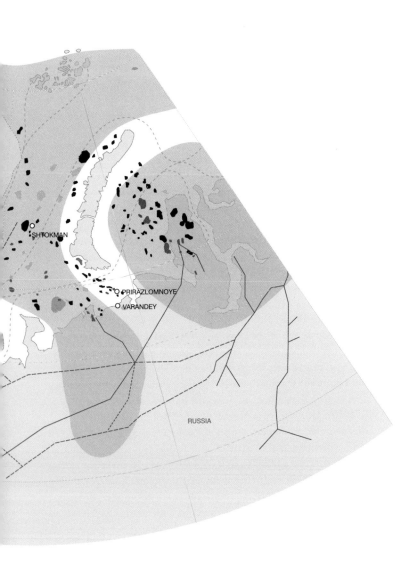

SHTOKMAN

PRIRAZLOMNOYE

VARANDEY

RUSSIA

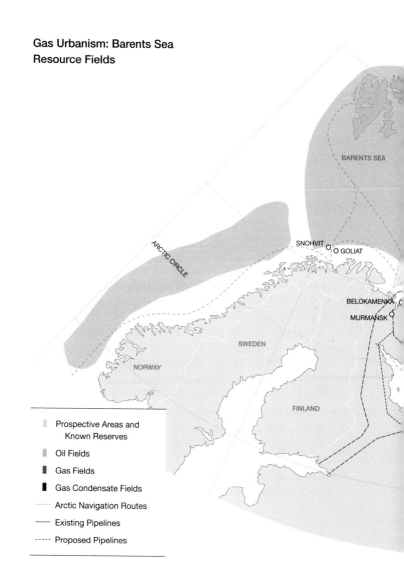

Gas Urbanism: Barents Sea
Resource Fields

BARENTS SEA

ARCTIC CIRCLE

SNOHVIT ○ ○ GOLIAT

BELOKAMENKA ○

MURMANSK ○

SWEDEN

NORWAY

FINLAND

- Prospective Areas and
 Known Reserves
- Oil Fields
- Gas Fields
- Gas Condensate Fields
- ----- Arctic Navigation Routes
- ——— Existing Pipelines
- ----- Proposed Pipelines

anchored in the port, currently serves as one of three offshore transshipment facilities in the bay.

The efficient transportation and processing of the Shtokman natural gas will be essential to the economic success of the development, and Russia has created a complex sea transport organization that includes an ice-breaking fleet, cargo ships, hydrographic support for Arctic mariners, a navigation-monitoring system, and of course, new Arctic ports. These on- and offshore facilities and services allow vessels to navigate the North Sea Route almost year round and under any hydrometeorological conditions.

Sakhalin Fields

Another frontier resource field that is experiencing a boom is in the North Pacific, off Russia's Siberian coast. The island of Sakhalin, a former penal colony, is at the center of this new development. The oil and gas reserves lying off its shores are expected to yield 14 billion barrels (2.2 cubic kilometers) of oil and 96 trillion cubic feet (2,700 cubic kilometers) of gas. The fields are named Sakhalin I through VI in the expected sequence of their phased development. Sakhalin I began production in October 2005 and reached full operating capacity in 2007.

At present, three platforms are at work in the region. The *Yastreb*, the world's most powerful land rig, anchors the Chayvo well site on Sakhalin's northeast coast. At over twenty-two stories high, it is capable of drilling extra-long, extended-reach wells to develop Chayvo field reservoirs nearly eleven kilometers off-shore. With the rig enclosed and heated to handle extreme

twist of fate, global climate change has raised temperatures enough over recent decades to make previously inaccessible areas thought to be resource fields now developable. One significant gas field called Shtokman was discovered in the Barents in 1988, 550 kilometers northeast of Murmansk, beyond helicopter range. Estimated to contain 3.7 trillion cubic meters of reserves, the Shtokman Field has inspired an innovative Arctic urbanism of a kind never seen before. Like the extensible, networked structures imagined by Japan's Metabolists in the 1960s, Shtokman will be an ever-evolving, self-extending organism of pipelines, tankers, platforms, rigs, living quarters, and more. The developers intend to extract the gas with the help of floating, ice-resistant platforms connected to the sea bottom with special templates, but which are also able to move out of the way of approaching icebergs. Gazprom, which owns 51 percent of the project, is constructing more than 3,000 kilometers of offshore and onshore pipelines, and has promised that Shtokman will come on stream by 2010.

Murmansk is strategically ideal for the exploitation of Siberian and Arctic fields because it remains ice-free throughout winter in spite of its location. The port is currently the region's largest coal-exporting facility, but when the Arctic shipping boom materializes the city is expected to grow rapidly into a new role as a major transport hub. In February 2008 a special economic zone was established around the port, and a new 25 million–tonne oil terminal on the western shore of the Kola Bay is planned. This will likely replace the massive *Belokamenka* supertanker, which, converted into a floating oil terminal and

Spar Platform

Floating Platform

1 STEEL TENDON
2 RISERS / WELLS
3 PILE CONNECTION
4 GAS PIPELINES
5 HARD TANK
6 SOFT TANK
7 TUBULAR RISERS
8 MOORING LINES
9 COMMUNICATION
 UMBILICALS

Icebreaker Tanker
Cuts Through + 3m Thick Ice
Double Hull

Floating Nuclear Power Plant

Gas Urbanism: Barents Sea
Infrastructure Typology

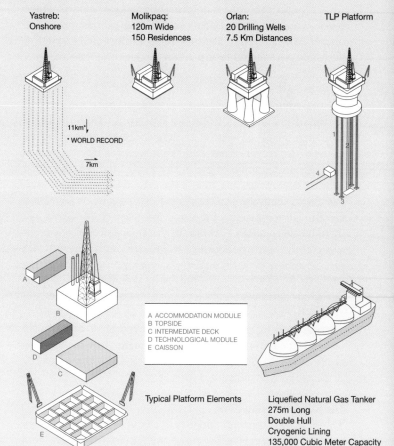

Yastreb:
Onshore

11km*
* WORLD RECORD

7km

Molikpaq:
120m Wide
150 Residences

Orlan:
20 Drilling Wells
7.5 Km Distances

TLP Platform

A ACCOMMODATION MODULE
B TOPSIDE
C INTERMEDIATE DECK
D TECHNOLOGICAL MODULE
E CAISSON

Typical Platform Elements

Liquefied Natural Gas Tanker
275m Long
Double Hull
Cryogenic Lining
135,000 Cubic Meter Capacity

In Russia, this process of intensified strategic infrastructural development has yielded what one could call *gas urbanism*. In the United Arab Emirates, the new urban forms — call them *slick cities* — are centered on luxury, leisure, and neo-capitalism

I: GAS URBANISM

The development of significant gas fields in the Arctic sea shelf off Russia has roused this former superpower from its recent economic slumber. Gazprom, a state-controlled conglomerate, oversees 16 percent of the world's gas reserves; the company is the biggest extractor of gas in the world, and it ranks third behind Saudi Arabia and Iran in the oil and gas reserves it controls. With almost 60 percent of the Russian economy accounted for through the export of raw materials, especially oil and gas, there has been an acceleration in the emergence of new technologies and infrastructure. An intricate network of highly specialized works of engineering is being put in place. Existing cities are being transformed but, more than that, a contemporary urban form centered on a constellation of extraction and processing infrastructure is being born. It is a city of tankers, platforms, ports, and pipe networks. Widespread and quickly diffused, the infrastructural city is like urban form in a gaseous state. Gas urbanism, like the state of matter, is without definite shape and of relatively low density.

The Shtokman Gas Field

The port of Murmansk (population 335,000), the largest city north of the Arctic Circle, sits on the Barents Sea, where, by a

In places as environmentally and culturally distinct as the Barents Sea, five hundred kilometers north of the Arctic Circle, and Dubai on the Persian Gulf, new and surprising urban morphologies are taking shape. These sites, among others, are fueled by the rapidly developing resource-based wealth of an overexcited global oil and gas market. Because the world is now consuming resources at more than twice the rate of their development and discovery, resource exploitation and urban development are closely aligned phenomena; the seeds of contemporary cities are often to be found in newly discovered resources or in the great wealth that has accrued to some small oil-spoilt states.

The uneven distribution of fossil fuels has enormous global implications: it has caused wars, economic strife, geopolitical instability, and environmental degradation. Hydrocarbon resources, especially petroleum and natural gas, and the threat of their depletion, have driven the economies of cities at an unprecedented rate. National economies around the world are envisioning and creating urban developments of a kind never seen before. These visions often materialize as large-scale, almost regional, conceptions of urban and infrastructural utopias. Islands, enclaves, infrastructural megaprojects, novelty super-towers, and off-shoring are the byproducts of exuberant global competition. Today, cities compete and evolve through intense urban marketing and branding: from billboards digitizing a new city to press releases announcing eco-village developments, the robust fantasies of the petro-dollar economy abound. Large-scale oil and gas development and superlative urbanism are fueled by global economic rivalries and competitive city-building.

RESOU

MASON
WHITE

FEL

GAS URBANISM 8
SLICK CITIES

Mosque
polyethylene container, Plexiglass
48" x 55" x 55"
1992
COURTESY THE ARTIST AND
GILLES PEYROULET ET CIE., PARIS

Fuel
retouched photograph
2003

Campfire
color photograph
2002

Tanker Crash, Ohio
color photograph
1992
ALL PHOTOGRAPHS COURTESY OF
THE ARTIST AND THE SUSAN HOBBS
GALLERY, TORONTO

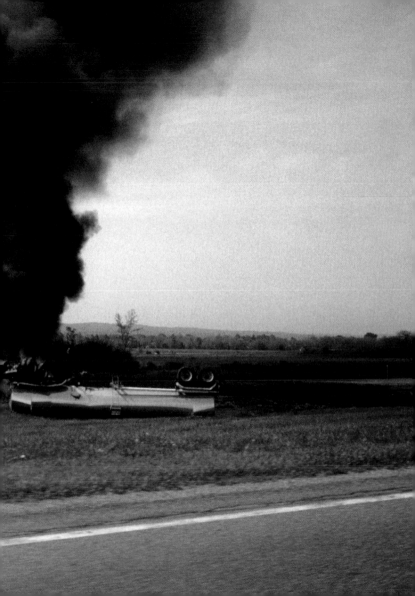

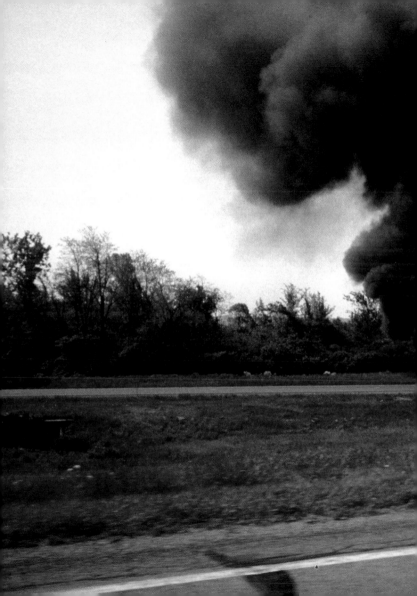

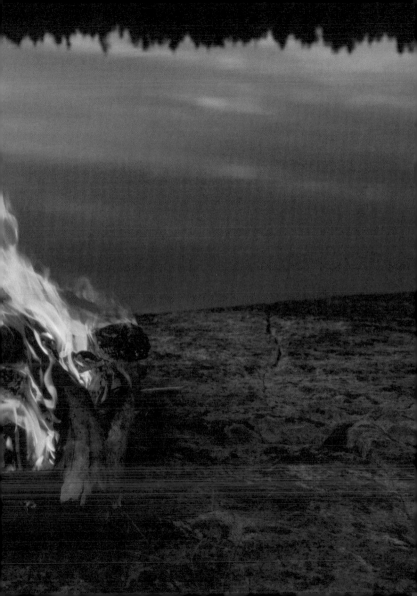

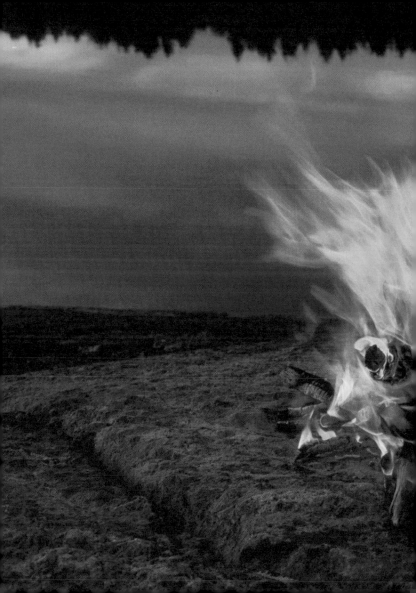

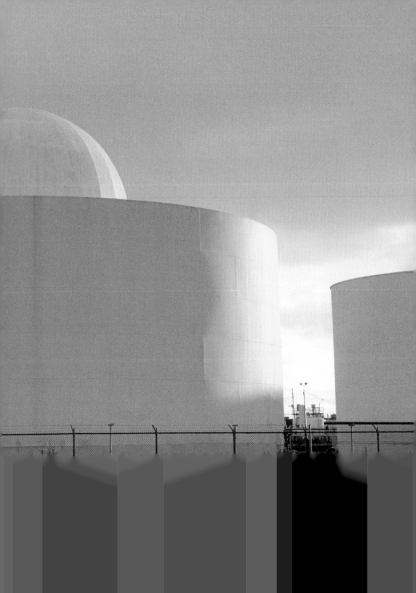

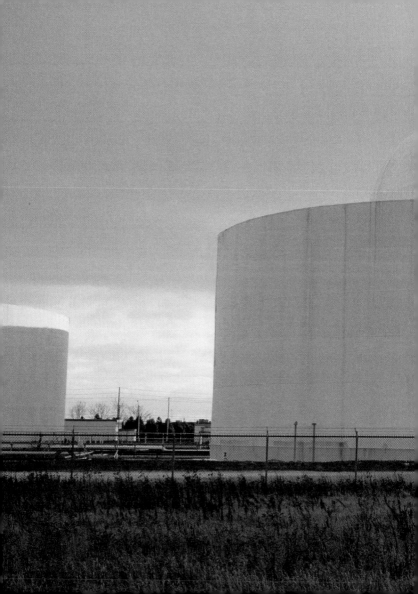

Oil Refineries #28
Houston, Texas
2004

Oil Refineries #7
Oakville, Ontario
1999

Oil Refineries #14
Saint John,
New Brunswick
1999

Oil Refineries #2
Oakville, Ontario
1999

Oil Fields #6
McKittrick, California
2002

Oil Fields #2
Belridge, California
2002

SOCAR Oil Fields #1a
(detail of diptych),
Baku, Azerbaijan
2006

Oil Sands #4
Fort McMurray, Alberta
2007

Oil Sands #15
Fort McMurray, Alberta
2007

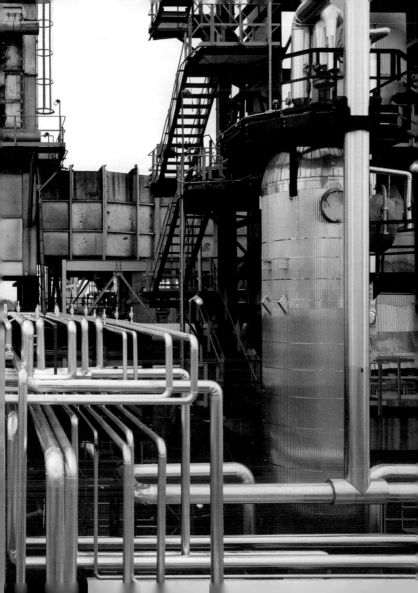

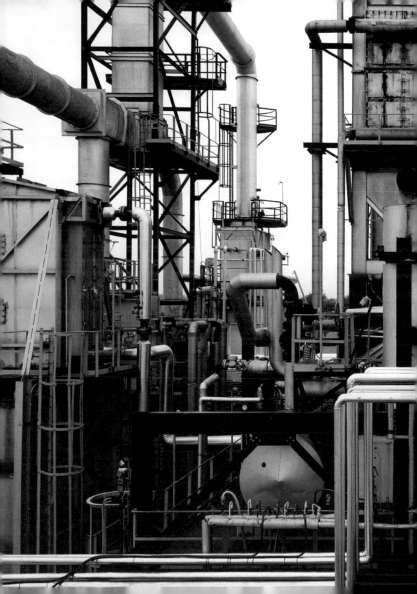

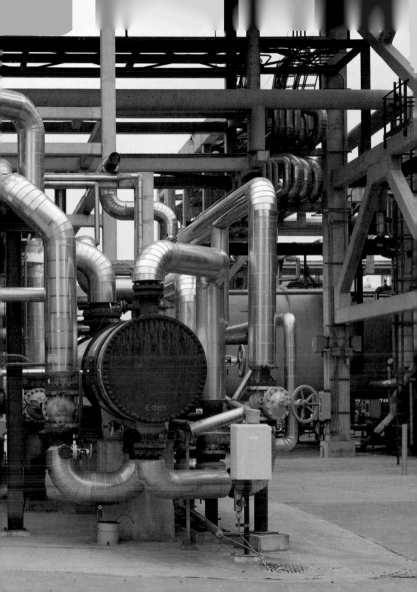

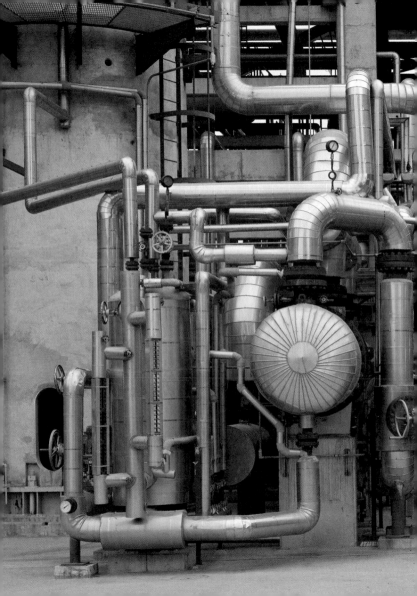

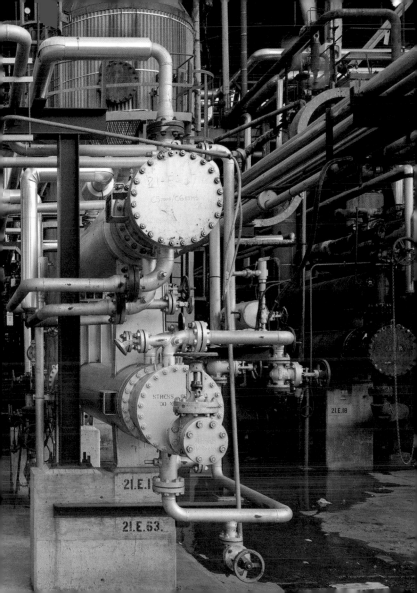

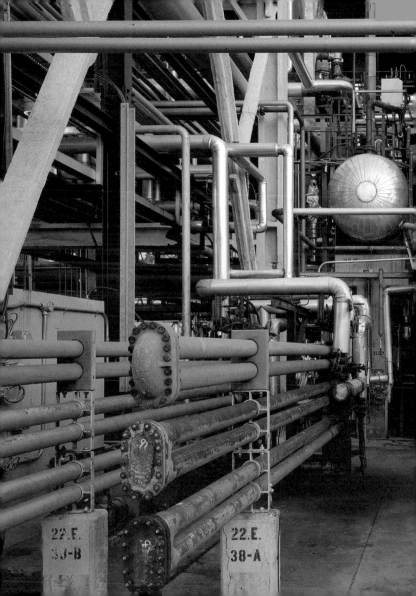

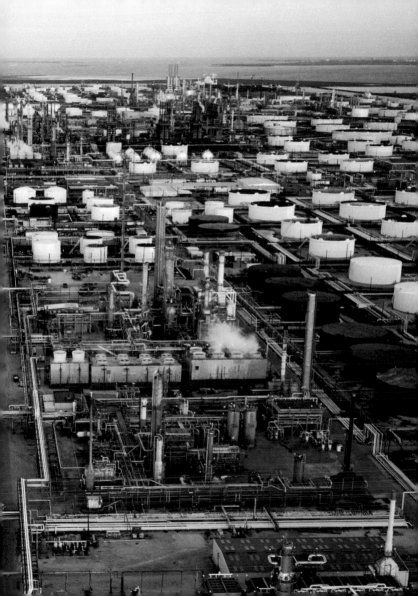

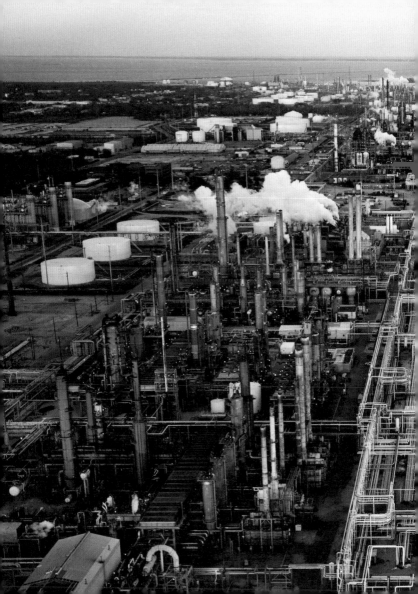

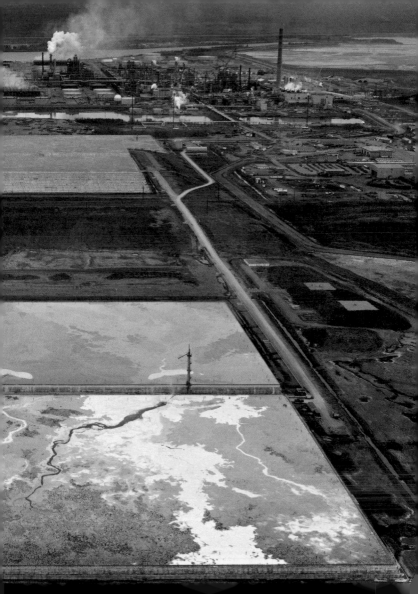